Bonnard

Page 4:
La Promenade, c. 1900.
Oil on canvas, 38 x 31 cm,
Private collection.

Designed by:
Baseline Co Ltd
19-25 Nguyen Hue
Bitexco Building, 11th floor
District 1, Hô Chi Minh-City
Vietnam

© 2005 Sirrocco, London, UK (English version)
© 2005 Confidential Concepts, worldwide, USA
© 2005 Bonnard Estate / Artists Rights Society, New York, USA / ADAGP, Paris

Published in 2005 by Grange Books
an imprint of Grange Books Plc
The Grange Kingsnorth Industrial Estate
Hoo, nr Rochester, Kent ME3 9ND
www.grangebooks.co.uk

ISBN 1-84013-772-X

Printed in China

"I agree with you that the painter's only solid ground is the palette and colors, but as soon as the colors achieve an illusion, they are no longer judged and the stupidities begin."

— Bonnard to Matisse, 1935

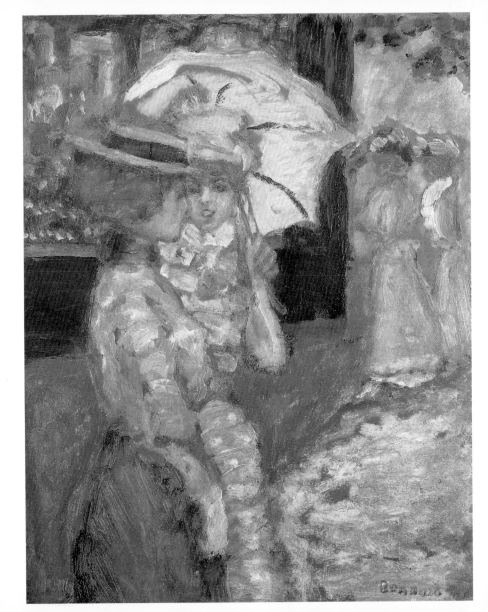

Biography

1867: Pierre Bonnard is born at Fontenay-aux-Roses near Paris.

1875: Enters the secondary school at Vanves, later attends the Lycées Louis-le-Grand and Charlemagne. Spends his summers at Grand-Lemps in the Dauphiné.

1886: Enters the Law Faculty of Paris University.

1887: Begins to study painting at the Académie Julian where he meets Paul Sérusier, Maurice Denis, Paul Ranson and Ibels.

1888: Leaves the University and enters the Ecole des Beaux-Arts.

1890: The exhibition of Japanese prints arranged at the Ecole des Beaux-Arts makes a deep impression on Bonnard.

1891: Shares a workshop with Vuillard and Denis in the Rue Pigalle. Though Denis becomes acquainted with Lugné-Poë, André Antoine and Paul Fort; works for the theatre. Enjoys his first success with the poster *France-Champagne*. Exhibits at the Salon des Indépendants and at the Gallery Le Barc de Boutteville.

1892: Turns to lithography. Is noted by such well-known art critics as Albert Aurier, Gustave Geffroy and Roger-Marx.

1893: Becomes acquainted with Marthe (Maria Boursin). Produces lithographs for the *Petites Scènes Familières* and the *Petit Solfège* by Claude Terrasse.

1896: First one-man show at the Durand-Ruel Gallery. Together with Vuillard and Maillol accepts an invitation to take part in the exhibition "La Libre Esthétique" in Brussels. Illustrates the novel *Marie* by Peter Nansen, published in the *Revue Blanche*.

1899: Vollard publishes an album of Bonnard's colour lithographs entitled *Quelques aspects de la vie de Paris*. Works on a large series of lithographs for Paul Verlaine's book of poems *Parallèlement*.

Bonnard

1900: Exhibits together with the other Nabis at the Bernheim-Jeune Gallery. Works in Paris and its environs: Montval, l'Etang-la-Ville, Vernouillet and Médan.

1902: Produces 156 lithographs for Longus's tale *Daphnis and Chloë*. Takes part in the Bernheim-Jeune exhibition. In the summer works in Colleville.

1904: Works at l'Etang-la-Ville and Varengeville. Illustrates Jules Renard's *Histoires naturelles*.

1905: Produces a series of nudes and portraits. Visits Spain.

1906: Exhibits landscapes and interiors at the Vollard Gallery. One-man show at the Bernheim-Jeune Gallery. In the summer sails on Misia Edwards's yacht to Belgium and Holland.

1908: Visits Italy, Algeria, Tunisia and Britain. Illustrates *628-E-8* by Octave Mirbeau.

1909: Works in Médan. In June goes to Saint-Tropez to visit Manguin.

1910: Works in the south where he regularly sees Signac and Renoir.

1911: Paints the triptych *Mediterranean* and the panels *Morning in Paris* and *Evening in Paris* commissioned by Ivan Morozov.

1912: Buys "Ma Roulotte", a small villa in Vernonnet, not far from Giverny. Often sees Claude Monet.

1913: Visits Hamburg together with Vuillard.

1916: Works on a series of large panels for the Bernheim-Jeune Gallery. In November goes on a trip to Winterthur.

1918: The Young Artists Society elects Bonnard and Renoir as honorary chairmen.

1919: Fosca and Werth publish the first books devoted to Bonnard.

1925: Buys a small house at Le Cannet. Officially marries Marthe.

1926: Travels to the United States to act as a member of the Carnegie Prize jury.

1936: Receives a Carnegie Prize for the second time (first award in 1923).

1939: Settles at Le Cannet.

1942: Marthe Bonnard dies.

1947: Pierre Bonnard dies at Le Cannet.

I n October 1947, the Musée de l'Orangerie arranged a large posthumous exhibition of Bonnard's work. Towards the close of the year, an article devoted to this exhibition appeared on the first page of the latest issue of the authoritative periodical *Cahiers d'Art*. The publisher, Christian Zervos, gave his short article the title "Pierre Bonnard, est-il un grand peintre?" (Is Pierre Bonnard a Great Artist?). In the opening paragraph Zervos remarked on the scope of the exhibition, since previously Bonnard's work could be judged only from a small number of minor exhibitions.

The Parade

1890
Oil on canvas, 23 x 31 cm
Private collection, Paris

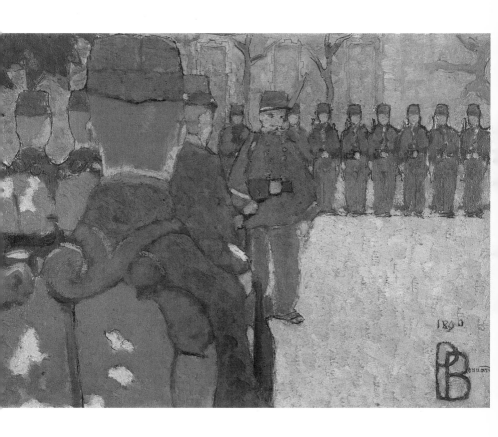

But, he went on, the exhibition had disappointed him: the achievements of this artist were not sufficient for a whole exhibition to be devoted to his work. "Let us not forget that the early years of Bonnard's career were lit by the wonderful light of Impressionism. In some respects he was the last bearer of that aesthetic. But he was a weak bearer, devoid of great talent. That is hardly surprising. Weak-willed, and insufficiently original, he was unable to give a new impulse to Impressionism,

Woman in the Garden

1891
Oil on paper mounted on canvas,
4 panels, 160 x 48 cm each
Musée d'Orsay, Paris

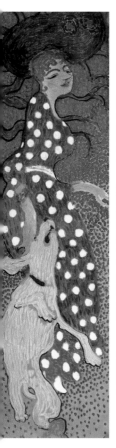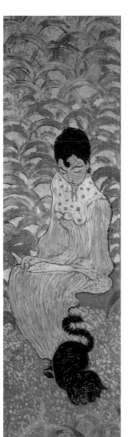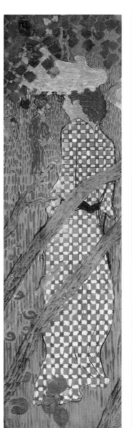

to place a foundation of craftsmanship under its elements, or even to give Impressionism a new twist. Though he was convinced that in art one should not be guided by mere sensations like the Impressionists, he was unable to infuse spiritual values into painting. He knew that the aims of art were no longer those of recreating reality, but he found no strength to create it, as did other artists of his time who were lucky enough to rebel against Impressionism at once. In Bonnard's works Impressionism becomes insipid and falls into decline."

Woman with Dog

───────────────

1891
Oil on canvas, 40.6 x 32.4 cm
Sterling and Francine Clark Art Institute, Williamstown

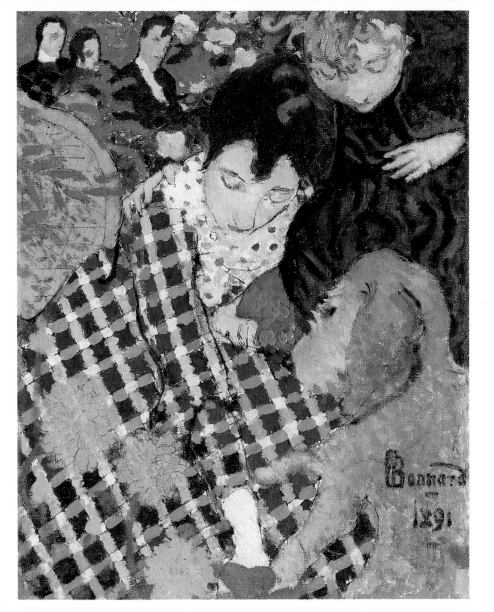

It is unlikely that Zervos was guided by any personal animus. He merely acted as the mouthpiece of the avant-garde, with its logic asserting that all the history of modern art consisted of radical movements which succeeded one another, each creating new worlds less and less related to reality. The history of modern art seen as a chronicle of avant-garde movements left little space for Bonnard and other artists of his kind. Bonnard himself never strove to attract attention and kept away altogether from the raging battles of his time.

Two Poodles

1891
Oil on canvas, 36.3 x 39.7 cm
Southampton City Art Gallery

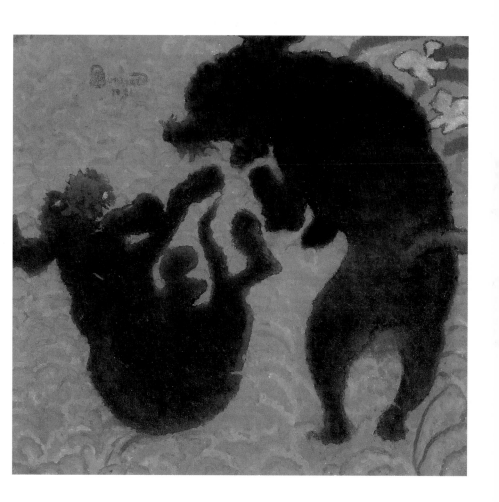

15

Besides, he usually did not stay in Paris for any length of time and rarely exhibited his work. Of course, not all avant-garde artists shared Zervos's opinions. Picasso, for example, rated Bonnard's art highly in contrast to his own admirer Zervos, who had published a complete catalogue of his paintings and drawings. When Matisse set eyes on that issue of *Cahiers d'Art,* he flew into a rage and wrote in the margin in a bold hand: "Yes! I maintain that Bonnard is a great artist for our time and, naturally, for posterity." Henri Matisse, Jan. 1948.

France-Champagne

———————

1891
Lithograph in 3 colours, 78 x 50 cm

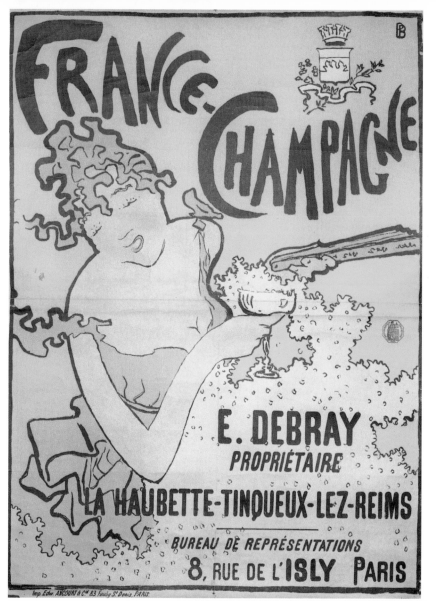

17

Matisse was right. By the middle of the century Bonnard's art was already attracting young artists far more than was the case in, say, the 1920s or in the 1930s. Fame had dealt strangely with Bonnard. He managed to establish his reputation immediately. He never experienced poverty or rejection unlike the leading figures of new painting who were recognised only late in life or posthumously — the usual fate of avant-garde artists in the first half of the twentieth century.

Intimacy

———

1891
38 x 36 cm
Musée d'Orsay, Paris

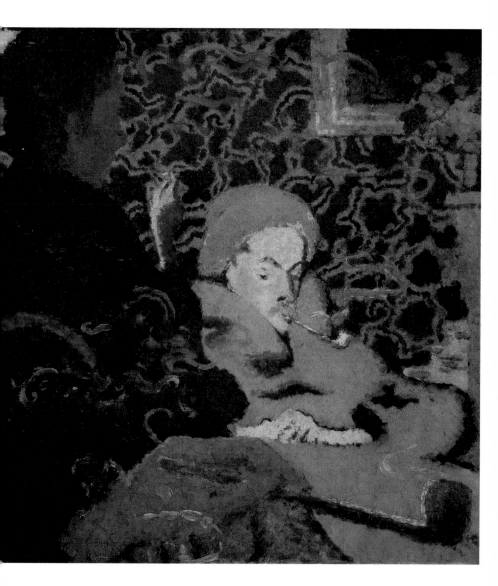

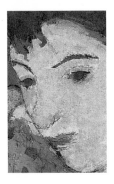

The common concept of *peintre maudit* (the accursed artist), a bohemian pauper who is not recognised and who readily breaks established standards, does not apply to Bonnard. His paintings sold well. Quite early in his career he found admirers, both artists and collectors. However, they were not numerous. General recognition, much as he deserved it, did not come to him for a considerable time. Why was it that throughout his long life Bonnard failed to attract the public sufficiently? Reasons may be found in his nature and his way of life. Bonnard rarely appeared in public, even avoiding exhibitions.

Tea in the Garden

1891
Oil, black ink and pencil on canvas,
38 x 46 cm
Private collection

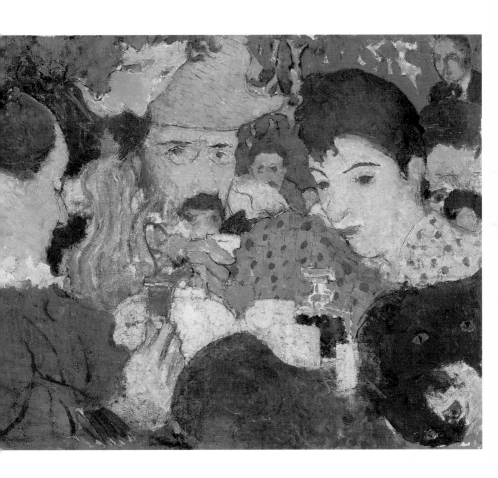

For example, when the Salon d'Automne expressed a desire in 1946 to arrange a large retrospective exhibition of his work, Bonnard responded to this idea in the following way: "A retrospective exhibition? Am I dead then?" Another reason lay in Bonnard's art itself: not given to striking effects, it did not evoke an immediate response in the viewer. The subtleties of his work called for an enlightened audience. There is one further reason for the public's cool attitude towards Bonnard. His life was very ordinary; there was nothing in it to attract general interest.

The Croquet Game

1892
Oil on canvas, 130 x 162 cm
Musée d'Orsay, Paris

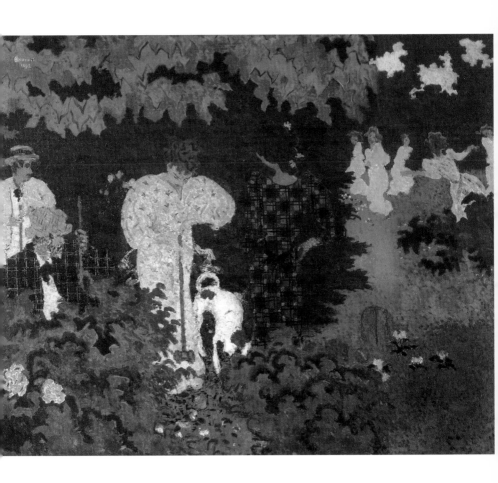

23

In this respect, it could not be compared with the life of Van Gogh, Gauguin or Toulouse-Lautrec. Bonnard's life was not the stuff legends are made of. And a nice legend is what is needed by the public, which easily creates idols of those to whom it was indifferent or even hostile only the day before. But time does its work. The attitude towards Bonnard's art has changed noticeably in recent years. The large personal exhibitions which took place in 1984-85 in Paris, Washington, Zurich and Frankfurt-am-Main had a considerable success and became important cultural events.

Portrait of Berthe Schaedlin

1892
Oil on cardboard, 31 x 16.5 cm
Galerie Daniel Malingue, Paris

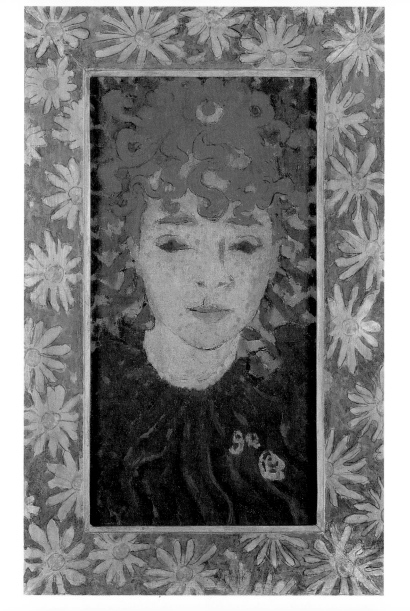

What was Pierre Bonnard's life like? He spent his early youth at Fontenay-aux-Roses near Paris. His father was a department head at the War Ministry, and the family hoped that Pierre would follow in his father's footsteps. His first impulse, born of his background, led him to the Law School, but it very soon began to wane. He started visiting the Académie Julian and later the Ecole des Beaux-Arts more often than the Law School. The cherished dream of every student of the Ecole was the Prix de Rome.

Family Scene

———————

1893
Colour lithograph, Hermitage, St. Petersburg

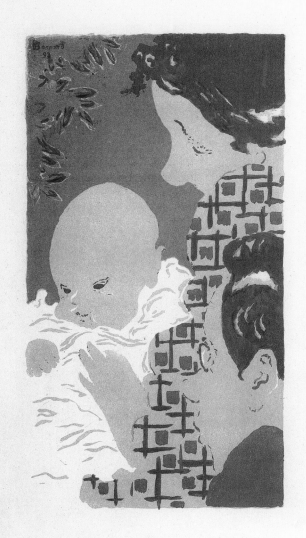

Bonnard studied at the Ecole for about a year and left it when he failed to win the coveted prize. His *Triumph of Mordecai,* a picture on a set subject which he submitted for the competition, was not considered to be serious enough. Bonnard's career as an artist began in the summer of 1888 with small landscapes painted in a manner which had little in common with the precepts of the Ecole des Beaux-Arts. They were executed at Grand-Lemps in the Dauphiné. Bonnard's friends — Sérusier, Denis, Roussel and Vuillard — thought highly of these works.

La Revue Blanche

1894
Lithograph in 4 colours, 80 x 62 cm

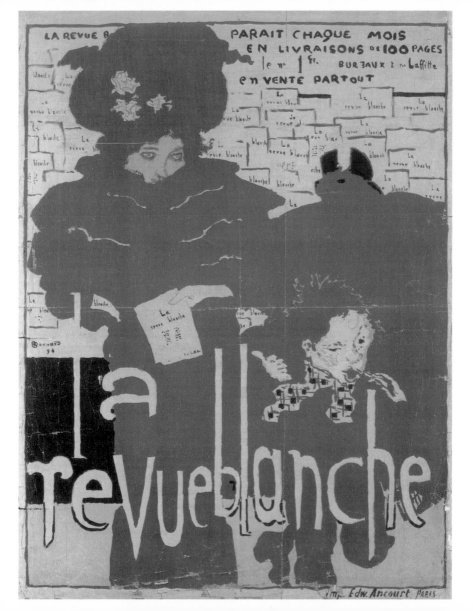

LA REVUE B PARAIT CHAQUE MOIS
EN LIVRAISONS DE 100 PAGES
le n° 1 fr. BUREAUX I rue Laffitte
en VENTE PARTOUT

La revue blanche

imp. Edw. Ancourt PARIS

Made in the environs of Grand-Lemps, the studies were simple and fresh in colour and betrayed a poetic view of nature reminiscent of Corot's.

Dissatisfied with the teaching at the Ecole des Beaux-Arts and at the Académie Julian, Bonnard and Vuillard continued their education independently. They zealously visited museums. During the first ten years of their friendship, hardly a day went when they did not see each other. And yet they addressed one another with the formal "vous", while Bonnard addressed other members of the Nabi group with "tu".

The White Cat

1894
51.5 x 33 cm
Musée d'Orsay, Paris

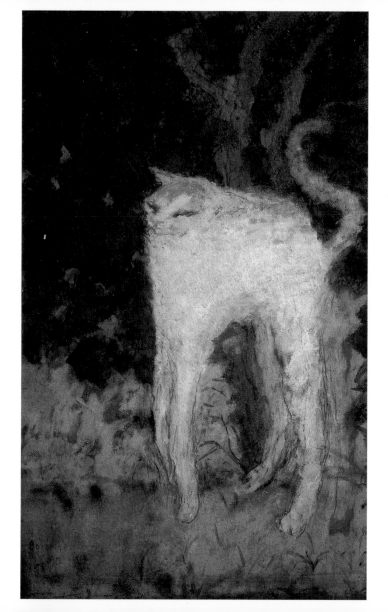

In the 1890s Bonnard was by no means a recluse. He loved to go for long walks with Roussel, even listened with pleasure to Denis's lengthy tirades, although he remained rather taciturn himself. He was sociable in the best sense of the word. One of his humorous reminiscent drawings (1910) shows the Place Clichy, the centre of the quarter where young artists, light-hearted and somewhat bohemian, usually congregated. Bonnard, Vuillard and Roussel are unhurriedly crossing the square.

Behind the Fence

1895
Oil on cardboard, 31 x 35 cm
Hermitage, St. Petersburg

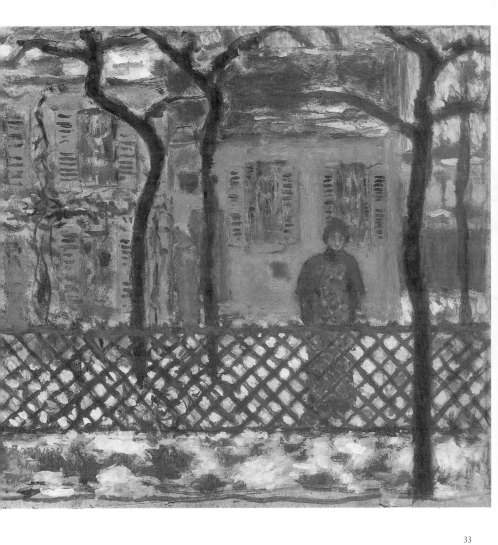

33

Some distance away, Denis is bustling along with a folder under his arm. Towards them, from the opposite direction, comes Toulouse-Lautrec, swinging a thick walking-stick. Toulouse-Lautrec was well disposed towards Bonnard and Vuillard. From time to time he would take their paintings, hire a carriage and drive to the art-dealers whom he knew personally. It was not easy to get them interested, though.

Child Eating Cherries

1895
Oil on board, 52 x 41 cm
National Gallery of Ireland, Dublin

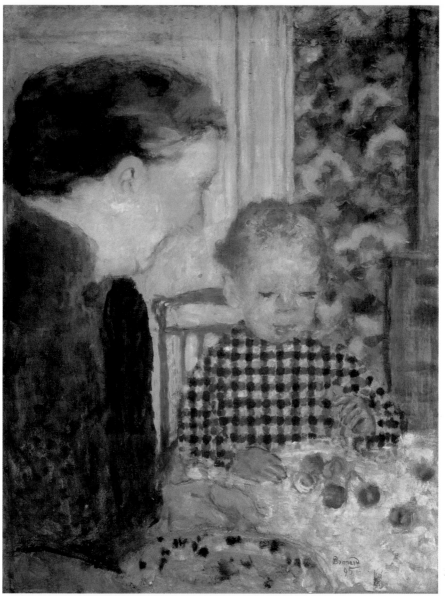

Toulouse-Lautrec greatly admired Bonnard's poster *France-Champagne* published in 1891. Bonnard took the artist to his printer, Ancours, in whose shop Toulouse-Lautrec's *Moulin Rouge* was printed later the same year followed by his other famous posters. The poster *France-Champagne,* commissioned by the wine-dealer Debray in 1889, was to play a special role in Bonnard's life. This work brought him his first emoluments.

The Carriage Horse

1895
Oil on wood, 30 x 40 cm
National Gallery of Art, Washington

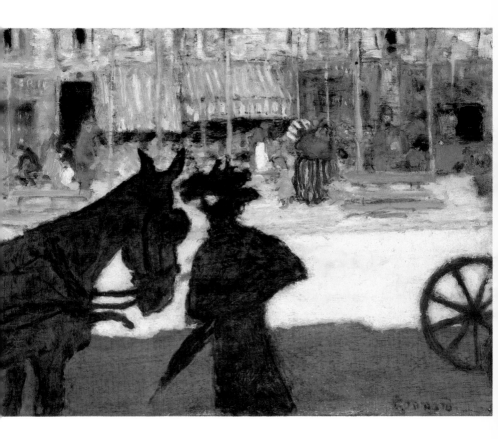

The sum was miserably small compared with the earnings of the then much-feted artist Jean Meissonnier, but it convinced Bonnard that painting could provide him with a living. This small success coincided with failure in his university examinations. Perhaps he was deliberately burning his boats, abandoning a career in business for the sake of art. On 9 March 1891 he wrote to his mother: "I won't be able to see my poster on the walls just yet. It will only appear at the end of the month. But as I finger the hundred francs in my pocket, I must admit I feel proud."

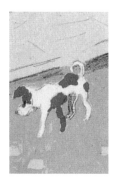

The Little Laundry Girl

1896
Lithograph in 5 colours, 30 x 19 cm

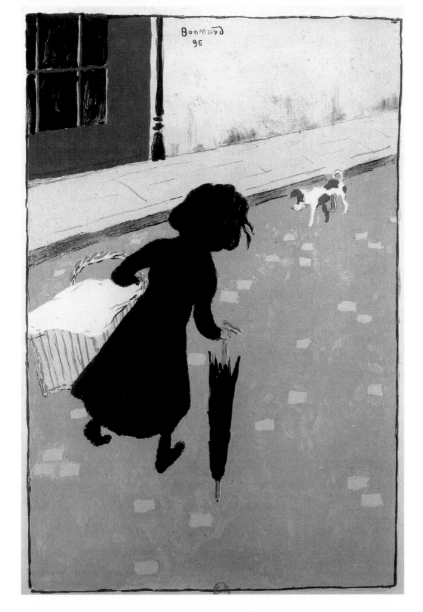

At about the same time he sent five pictures to the Salon des Indépendants. At the close of 1891 he exhibited his works together with Toulouse-Lautrec, Bernard, Anquetin and Denis at Le Barc de Boutteville's. When a journalist from *Echo de Paris,* who interviewed the artists at the exhibition, asked Bonnard to name his favourite painters, he declined to do so. He said that he did not belong to any school. His idea was to bring off something of his own and he was trying to forget all that he had been taught at the Ecole des Beaux-Arts.

The Bridge

1896-1897
Lithograph in 4 colours, 27 x 41 cm

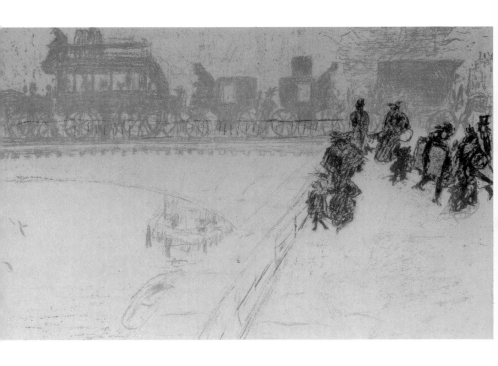

One more event in 1891 played an important role in Bonnard's life. The journal *Revue Blanche* moved its editorial office from Brussels to Paris. Bonnard and other members of the Nabi group soon established a good relationship with the publisher Thadée Natanson, another former student of the Lycée Condorcet. Natanson managed to get the most gifted artists, writers and musicians to work for him. The frontispieces of the journal were designed by Bonnard and Vuillard; inside there were the latest poems of Mallarmé,

The Big Garden

c. 1897-1898
Oil on canvas, 167.5 x 220 cm
Musée d'Orsay, Paris

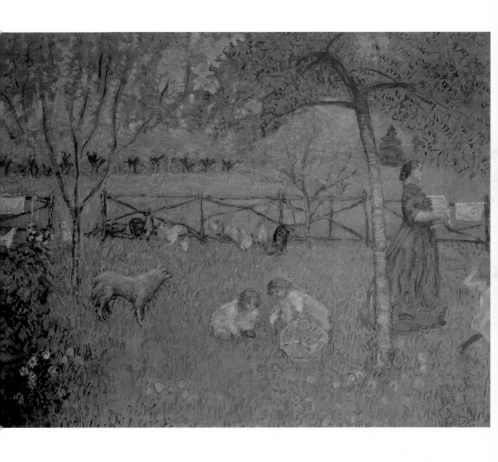

works by Marcel Proust and Strindberg, Oscar Wilde and Maxim Gorky; Debussy also contributed. On the pages of the *Revue Blanche* literary critics discussed the works of Leo Tolstoy. Natanson himself devoted his first article to Utamaro and Hiroshige. Without exaggeration, the *Revue Blanche* was the best French cultural periodical of the 1890s. The atmosphere in its editorial office, which the Nabis often visited, was stimulating.

Landscape in the Dauphiné

c. 1899
Oil on panel, 45.5 x 56 cm
Hermitage, St. Petersburg

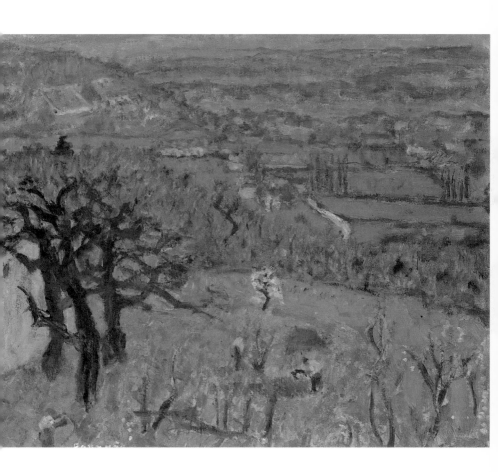

Natanson's personal support for the artists was also of no small importance. He was as young as the artists whom he backed and was not afraid to follow his own inclinations. Even Natanson's friends later admitted that at times they had doubts about whether they could trust a person who decorated his home with works by Bonnard and Vuillard.

Natanson's printed reminiscences of Bonnard give perhaps one of the best pen-portraits of the artist. "Bonnard, when I first met him, was a gaunt young man who sometimes stooped.

The Meal

———

1899
Oil on panel, 30.5 x 38.7 cm
Private collection

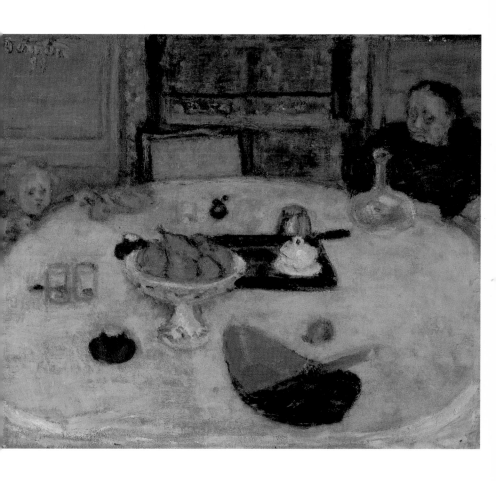

He had very white slightly protruding front teeth, was timid and short-sighted. His dark brown rather thin side-whiskers curled slightly; perched on his nose, very close to his eyes with the dark pupils, was a small pince-nez in an iron frame, as was the fashion at the close of the nineteenth century. He spoke little, but was always ready to show the portrait of his fat grandmother in whose house he lived when he first came to Paris. The portrait had been painted in the Dauphiné and depicted the old lady with several white hens pecking at some feed close to her skirts.

Lunch

———

1899
Oil on board, 55 x 70 cm
Stiftung Sammlung E.G. Buhrle, Zürich

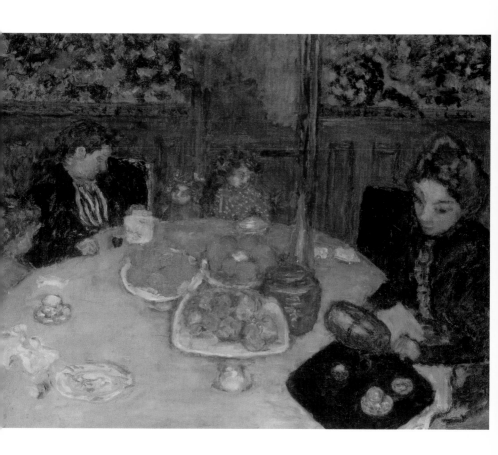

My new friend behaved in a very guarded manner when it came to discussing theories in painting, but he readily spoke about Japanese prints of which he was very fond. At that time such a taste could be easily satisfied. He also preferred checked fabrics far more than any other kind. His smile, with his white teeth showing slightly, was so winning that you wanted to see it again and to hold on to it. You wanted to catch the moment when it appeared. Bonnard smiled out of politeness, because of his shyness, but once he had tamed his smile,

Indolence (preliminary version)

c. 1899
Oil on canvas, 92 x 108 cm
Josefowitz collection

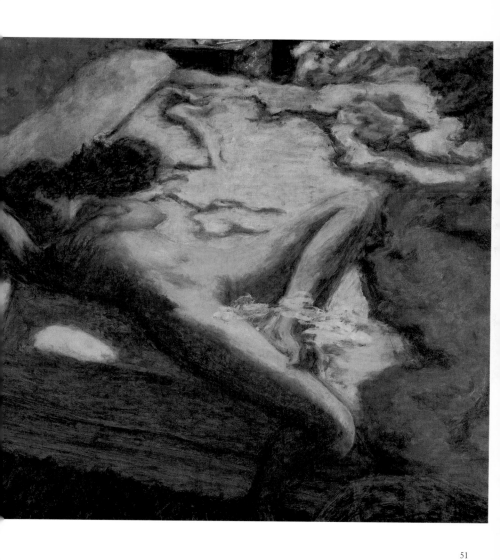

so to speak, he was no longer inhibited, and it was as if a tensioned spring had unwound… Bonnard hardly changed from the early days of our friendship. He rarely livened up, even more rarely expressed his mind openly, avoiding any possible chance of letting his feelings come out into the open." "He was the humorist among us," Lugné-Poë recalled. "His light-hearted jollity and wit can be seen in his canvases". "Wonderfully gifted, but too intelligent to let us feel his superiority, he was able to hide the spark of genius within him," was Verkade's recollection of him.

Nude with Black Stockings

c. 1900
Oil on panel, 59 x 43 cm
Private collection, on loan to City
of Sheffield Art Galleries

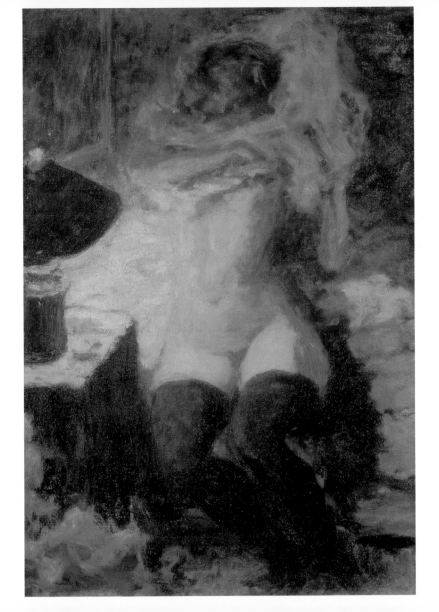

Bonnard's humour was perhaps not always taken as harmless. The Russian artist Alexander Benois said that his acquaintance with the painter in the late 1890s was short-lived because Bonnard's specifically French *esprit gouailleur* (mocking wit) made him feel ill at ease. But Benois's reaction is exceptional. There was nothing of the born joker about Bonnard, and as he grew older he became increasingly reserved, even somewhat distrustful of others.

Man and Woman

1900
Oil on canvas, 115 x 72 cm
Musée d'Orsay, Paris

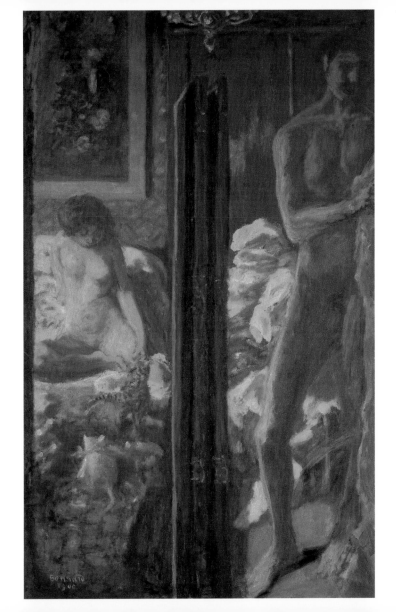

55

In fact, throughout his life, even when he was a member of the Nabi group, he required the company of others less than his own; or rather what he needed was to be left alone with his art. Natanson was right when he said that Bonnard's misanthropy sprang from his innate kindness. But even in his youth Bonnard was probably a more complex personality than he seemed to his friends. His reserve and reticence hid traits which one could hardly suspect. In his self-portrait painted in 1889 (private collection, Paris) we see not a light-minded wit, but a watchful, diffident young man.

Young Woman by Lamplight

c. 1900
Oil on canvas, 61.5 x 75 cm
Musée des Beaux-Arts, Berne

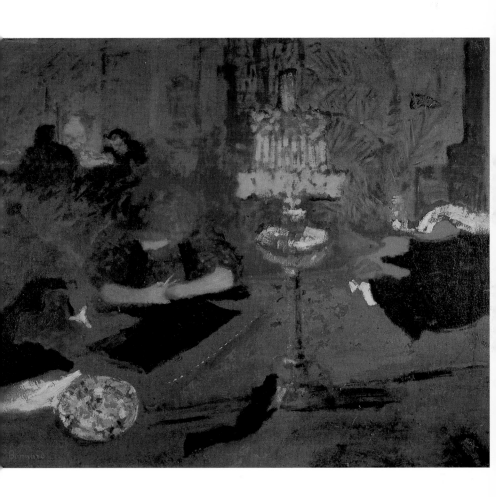

The still eyes hide thoughts one does not usually share with others. His acquaintances saw him as a fine, jolly fellow. And that was true enough. But was that all? With age, other hidden features of his nature became more evident. At thirty, when Benois met him, he was a different man from the one he was at the age of twenty: he was less light-hearted and showed less desire to surprise with paradoxes. So many of his early compositions were deliberately paradoxical.

The Siesta

———

1900
Oil on canvas, 109 x 132 cm
National Gallery of Victoria, Melbourne

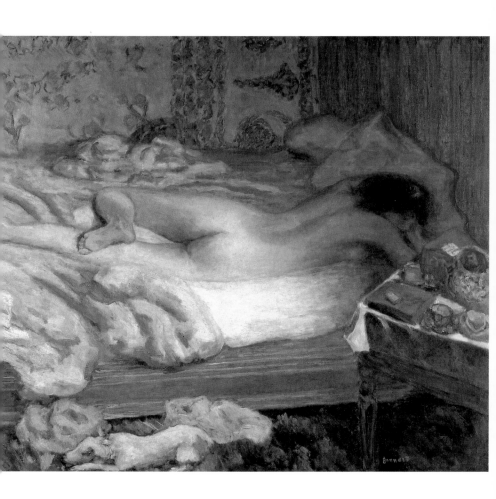

In 1891 Bonnard told a correspondent from the *Echo de Paris* that painting should be predominantly decorative, that the disposition of lines revealed true talent. Three or four years later he began to move away from intricate decorative effects and deliberate complexity towards a greater liberation of colour and a living texture in painting, as well as towards its inner integrity. This was a turning point in his career, but it did not occur suddenly.

The Terrasse Family
(L'Après-midi bourgeoise)

1900
Oil on canvas, 139 x 212 cm
Musée d'Orsay, Paris

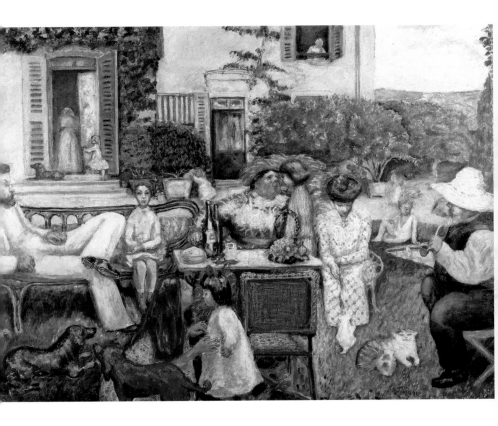

Changes in Bonnard's painterly manner accumulated gradually, and for this reason it is impossible to draw a dividing line between one period and another. But changes did take place. When looking at a picture executed in the new manner, one cannot help feeling that it is not so much a different picture as the earlier one transformed, but that the newer picture represents a deeper understanding of what the artist was doing before.

Promenade

c. 1900
Oil on canvas, 38 x 31 cm
Private collection

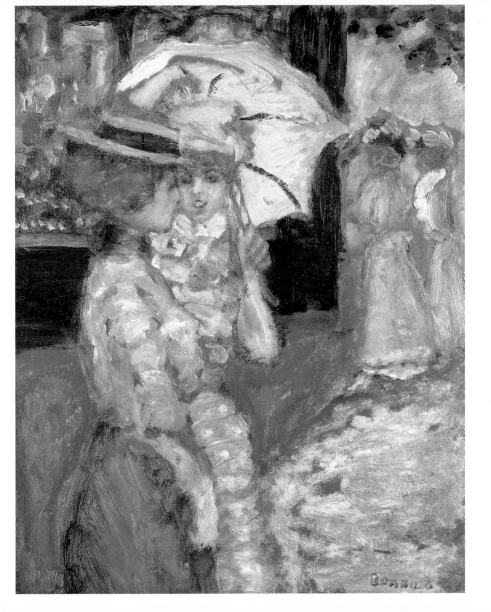

While developing his talent, Bonnard at the same time remained true to himself. Bonnard's invariable loyalty to himself and to his views on life is always expressed in his art. Throughout the sixty years of his career he remained true to the subjects of his youth, but none of his works is mere dreary repetition. His artistic individuality is easily recognizable in each new work. Bonnard's intonations often have humorous overtones.

The Family in the Garden

c. 1901
Oil on canvas, 109.5 x 127.5 cm
Kunsthaus, Zürich

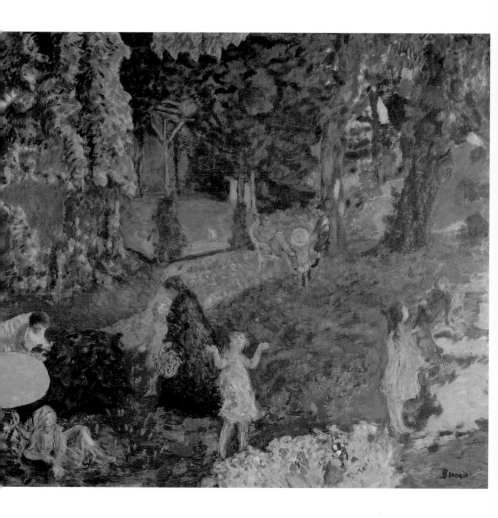

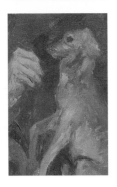

Benois saw this as the source of the superficiality for which he reproached the artist. There might have been an element of truth in this, if Bonnard's humour were present in all circumstances. But he used humour only when he wanted to avoid the direct expression of emotions. In a way, his special form of tact was akin to that of Chekhov. Though there was never any personal contact between these two men, they had much in common.

Misia and Thadée Nathanson

1902
Oil on canvas, 130 x 86 cm
Musée d'Art Moderne, Brussels

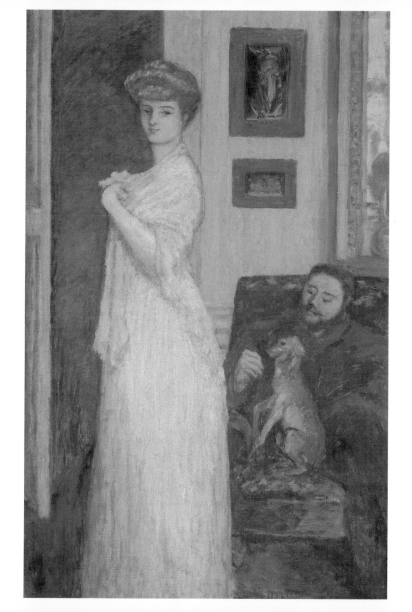

Bonnard always added a touch of humour when he depicted children. The ploy reliably protected him against the excessive sentimentality often observed in this genre.

Bonnard had no children of his own. For many years he led a bachelor's life. This seemed not to worry him in the least. If, however, one looks at his works as a kind of diary, a rather different picture emerges. In the 1890s-1900s he often depicted scenes of quiet domestic bliss.

The Pont du Carrousel

c. 1903
Oil on canvas, 71.4 x 100 cm
Los Angeles County Museum,
Gift of Mr and Mrs Sidney F. Brody

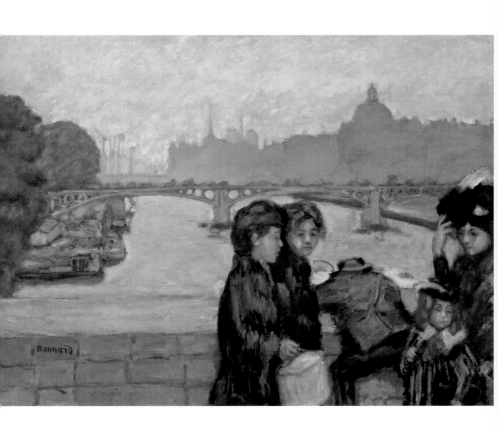

These scenes — the feeding of a baby, children bathing, playing or going for walks, a corner of a garden, a cosy interior — are both poignant and amusing. Of course, these aspects of life attracted the other Nabis, too, which was in keeping with the times. But in Bonnard's work these motifs are not treated with stressed indifference, as in Vallotton's. Bonnard does not conceal the fact that he finds them attractive.

Charles Terrasse as a Child

1903
47 x 43 cm
Location unknown

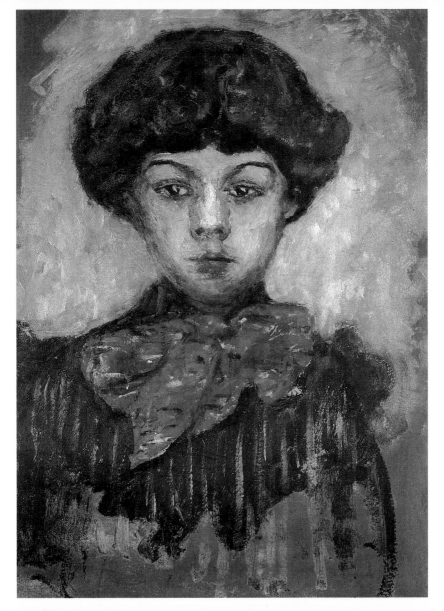

Yet it is not easy to discern a longing for family life in his work. One might suggest it but without much confidence. Bonnard seems to remind himself, as always with humour, that family life is undoubtedly emotionally pleasant, but there is much in it that is monotonous and even absurd — a truly Chekhovian attitude. The many commonplace situations treated on account of banality with a degree of humour are summed up in the monumental portrait of the Terrasse family, a work unprecedented in European art.

Young Woman Seated on a Chaise Longue

c. 1904
53 x 60 cm
Location unknown

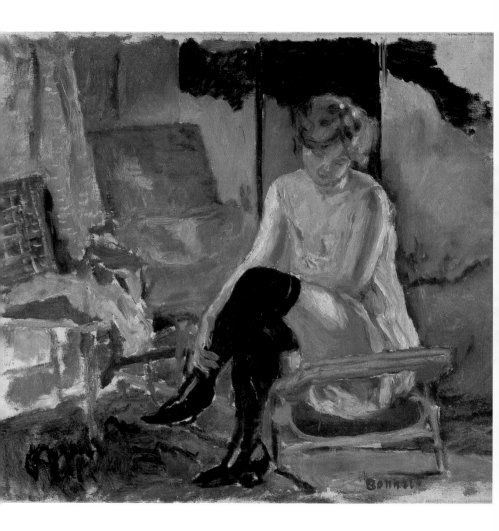

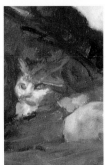

Bonnard gave the picture the title *The Terrasse Family (L'Après-midi bourgeoise)*. It was painted in 1900 and is now in the Bernheim-Jeune collection in Paris (another version is in the Stuttgart State Gallery). The title parodies Mallarmé's eclogue *L'Après-midi d'un faune*. The artist had affection for his characters and not only because they were his relatives (Bonnard's sister Andrée was married to the composer Claude Terrasse).

Ambroise Vollard

c. 1904-1905
Oil on canvas, 74 x 92.5 cm
Kunsthaus, Zurich

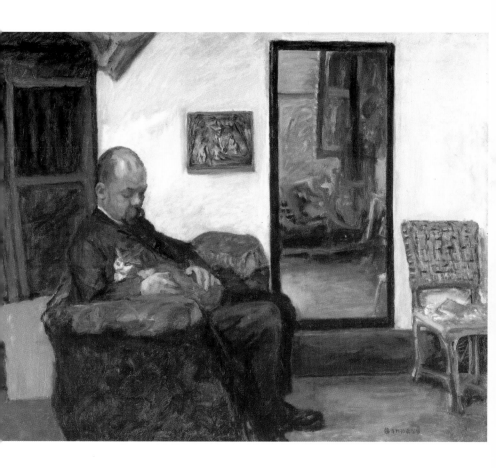

Yet he depicted the dozen or so of them in an ironical parade of provincial idleness, in all its grandeur and its absurdity.

Around the same time Bonnard painted his *Man and Woman* (1900, Musée d'Orsay, Paris), a work with a psychological dramatism quite unexpected for the artist. The psychological aspect of the work is not a piece of fiction or illustration of the then fashionable subject of the conflict between the sexes; it is a self-portrait of the artist with Marthe, his constant companion and model, in every respect a deeply personal work.

A Corner of Paris

c. 1905
Oil on cardboard pasted on parqueted panel,
49.2 x 51.8 cm
Hermitage, St. Petersburg

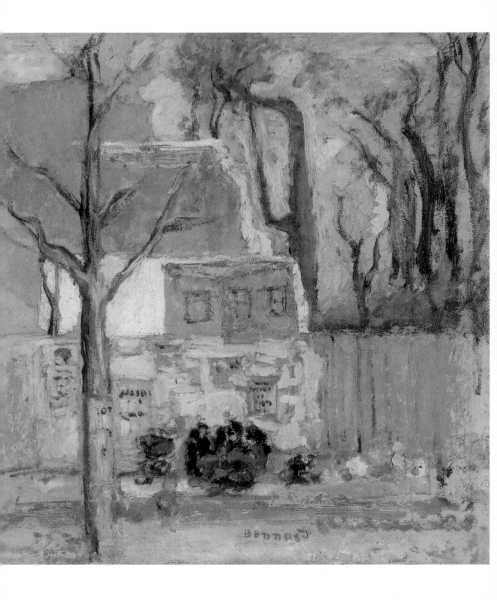

Of course, this painting is not typical of Bonnard: there is no irony here; we are witnessing a dramatic episode easily identified as biographical. Both this work and the portrait of the Terrasse family are worthy of attention, because they show Bonnard not only as a subtle painter but also as a very complex personality. Meeting Marthe brought many changes to Bonnard's life.

The Red Garters

c. 1905
Oil on canvas, 61 x 50 cm
Private collection

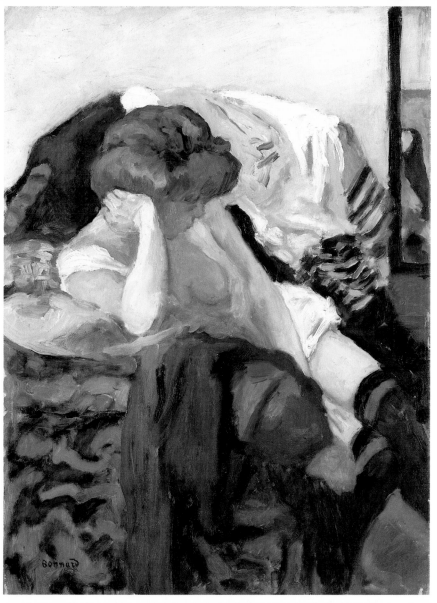

This girl, who had come to Paris in search of work and a new life, did not belong to the same social milieu as Bonnard, and in comparison with him and his friends she was practically uneducated. Yet she became the artist's muse. In her, Bonnard found an inexhaustible source of inspiration. She did not sit specially for him, and "there was no need for this because she was constantly with him. Her movements flowed out of one another with a naturalness that can be neither learnt nor forgotten.

Pleasure
———
1906
Oil on canvas, 250 x 300 cm
Galerie Maeght, Paris

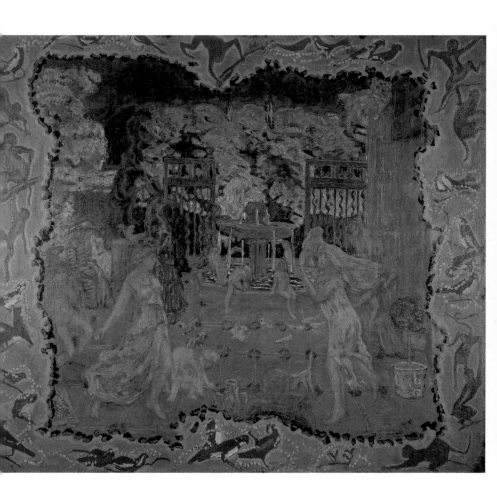

Some of Bonnard's most brilliant pictures were prompted by some pose of her body which he had noticed." The presence of Marthe, the mistress of the house, is unexpectedly revealed in *Mirror in the Dressing-Room,* now in the Pushkin Museum of Fine Arts in Moscow. In the mirror we can see the reflection of a small room in which Marthe is drinking coffee, completely ignoring the model who is in the act of removing her clothes.

Standing Nude
―――――――――
1906
Oil on canvas, 140 x 80 cm
Private collection

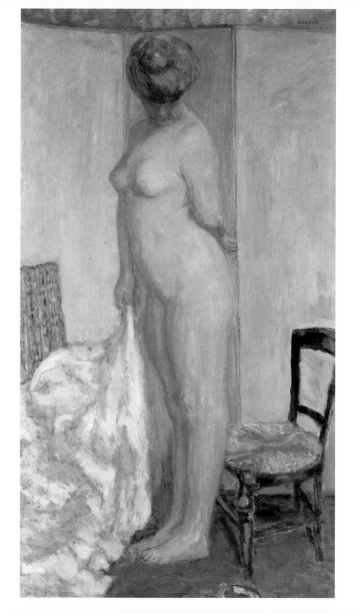

They say that it was Bonnard's wife who compelled him to lead a secluded life, striving by one means or another to keep him away from his friends and from Paris. Through the years she indeed became an intolerable person. But there is no evidence that Bonnard ever complained or expressed dissatisfaction. He was a patient man, and his love was a wise one. Perhaps he lacked firmness of character. "He was always afraid of her, her tactless behaviour," Matisse recalled.

Woman Leaning Over

—————————————

1907
Oil on canvas, 72 x 85 cm
Niigatashi City Art Museum

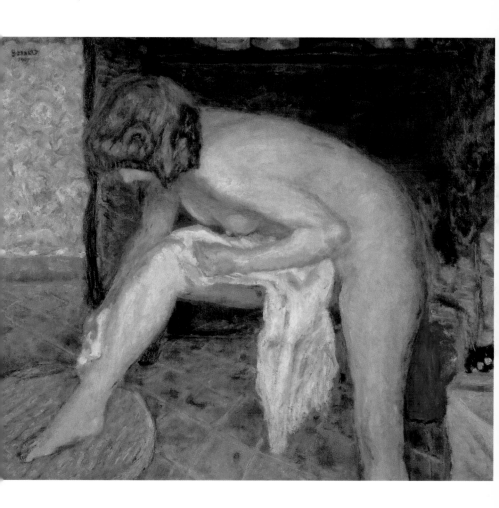

"She tried to cut him off from everyone. True, she received me, saying, 'Oh, Matisse is only concerned with his painting.' I suppose she thought I wasn't dangerous." Bonnard's friends were definitely convinced that he was under Marthe's thumb. But in actual fact he submitted himself to the imperatives of his art and Marthe never infringed upon them. He found it convenient to live in rural solitude and devote all his time to his work.

In the Bathroom

1907
Oil on board, 107 x 72 cm
Private collection, Lausanne

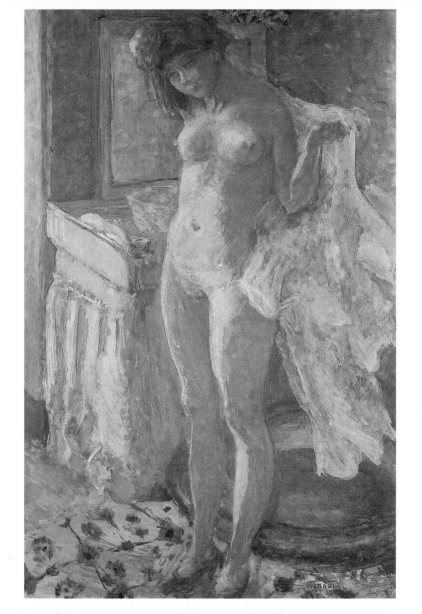

After the First World War, if he visited Paris at all, he never spent more than two months in any year in the capital. "I go there to see what's happening, to compare my painting with that of other artists. In Paris I am a critic, I can't work there. There is too much noise, too many distractions. I know that other artists become accustomed to that kind of life. I find it difficult." Bonnard had indeed changed; he seemed to have forgotten what fascination the rush and bustle of Paris had once held for him.

Mirror in the Dressing Room

1908
Oil on canvas, 120 x 97 cm
Pushkin Museum of Fine Arts, Moscow

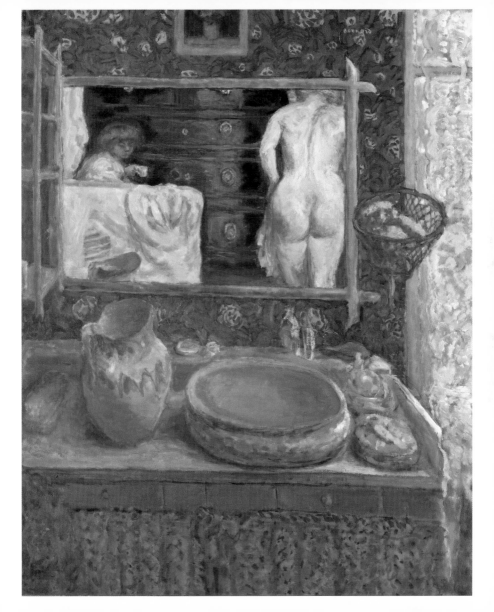

Bonnard visited many foreign countries, but his travels left no noticeable traces in his art, which had grown on French soil, in a French atmosphere. Paris and the Ile-de-France, Normandy, the Dauphiné, and the Côte d'Azur were places where Bonnard worked. In summer he usually went to some little town or village in one of these French provinces. He was particularly fond of Vernon and Le Cannet. Bonnard was an artist of unusual integrity.

The Cherry Tart

1908
Oil on canvas, 115 x 123 cm
Private collection, Zürich

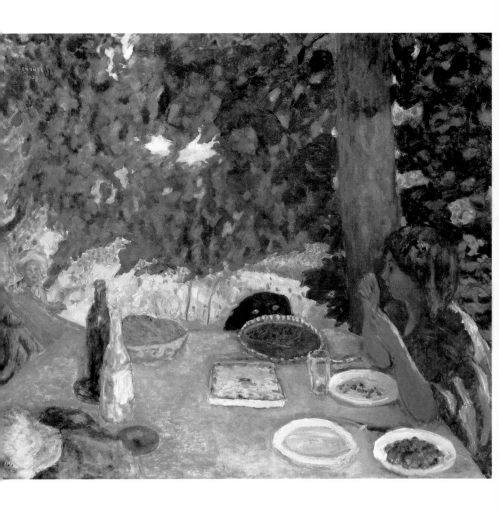

A scholar who attempted to divide his work into periods would find himself faced with a formidable task. His early works are marked by a deliberate decorativeness, while towards the close of his life his paintings become more expressive; at times this expressiveness is accompanied by dramatic overtones. However, it is impossible to establish a point when one tendency exhausted itself and another became a dominant feature of his art.

Misia with Roses

1908
Oil on canvas, 114 x 146.5 cm
Private collection

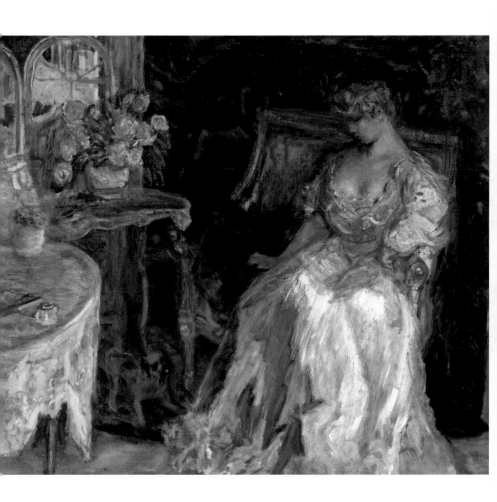

One is forced inevitably to the conclusion that the whole of Bonnard's enormous legacy constitutes a single period. The works painted between 1888 and 1890, about 15 in all (earlier works have not come down to us), already clearly indicate which genres the artist preferred: landscapes, still lifes and portraits. They also include his panel *The Peignoir* (1889, Musée d'Orsay, Paris), which is as decorative as a textile, and spontaneous, lively compositions containing human figures — the type favoured by the Impressionists.

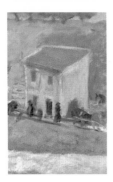

Early Spring

1908
Oil on canvas, 87.6 x 132.1 cm
The Phillips Collection, Washington, DC

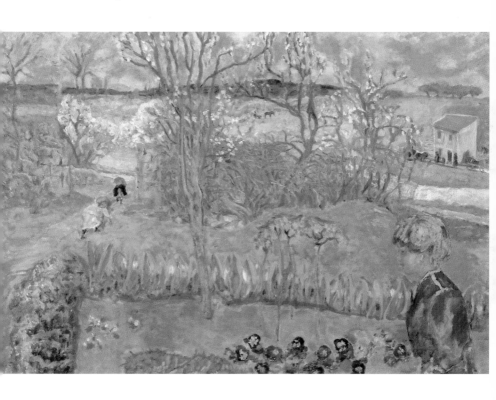

An example of the latter is *Street* (1889, Milliner collection, Paris), the first of the artist's small genre scenes set in Paris, each of which is unique in its own way. This picture is the prototype for *Morning in Paris* and *Evening in Paris,* paintings now in the Hermitage.

Street and another painting of this period, *Woman in the Garden* (private collection, Paris), show that Bonnard not only was well acquainted with Impressionism, but he ventured into its territory as a polemist rather than a timid pupil: here characteristic Impressionist motifs are treated in a far from Impressionistic manner.

Misia
———
1908
Oil on canvas, 145 x 114 cm
Fondaçion Coleccion Thssen-Bornemisza, Madrid

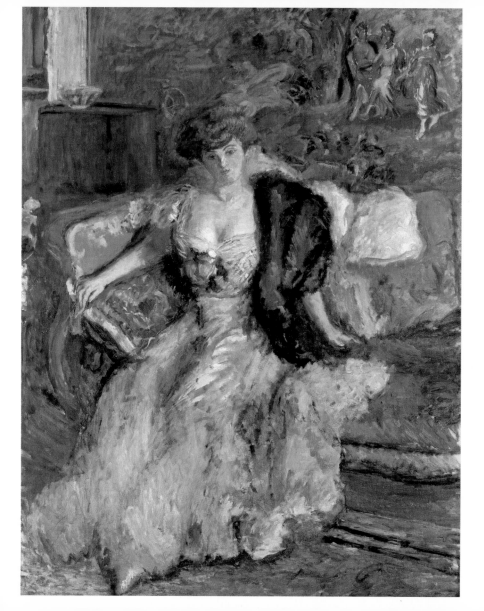

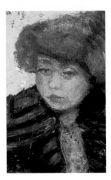

It was only a short time before Bonnard painted these pictures that the Nabis learned the lesson taught by Gauguin. However, Bonnard and Vuillard with him were influenced to a lesser degree by Gauguin than their companions. While sharing Gauguin's opposition to Renoir, Pissarro and Raffaëlli, Bonnard and Vuillard drew support not from Gauguin, but from oriental art, mainly from Japanese prints. French artists had become interested in Japanese art even before Bonnard was born.

The Gardener

1908
Oil on canvas, 85 x 93 cm
Private collection

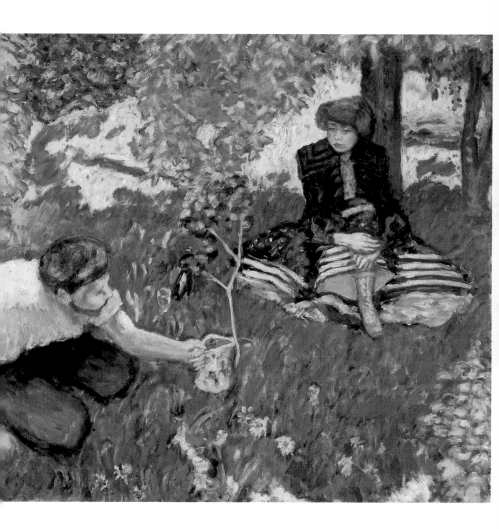

The influence may be traced in Manet's work and particularly in all the early works of the Impressionists. Originally it was no more than a taste for the exotic, but in the latter part of the 1880s this interest became more profound, and France was swept by a real wave of enthusiasm for Japanese art. Comparing French paintings of that period with Japanese prints, art historians have discovered that Monet, Degas, Redon, Gauguin, Seurat, Signac and others borrowed both motifs and elements of composition from these prints.

Nude Against the Light

—————————————

1908
Oil on canvas, 124.5 x 108 cm
Musée Royaux des Beaux-Arts de Belgique, Brussels

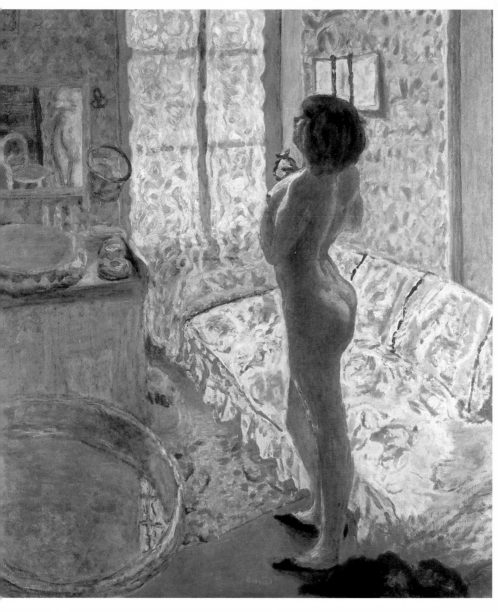

Van Gogh painted his own versions of Japanese prints. He even went to Provence hoping to find a second Japan there. To one degree or another, all the Nabis used devices prompted by Japanese woodcuts. Yet it was no coincidence that one of them was singled out for the nickname "the Highly Nipponised Nabi" (Nabi Très Japonard). It is quite reasonable to link Bonnard's early urban scenes, including his *Street*, and the works not only of the Impressionists, but also of Japanese artists — all the more so because the Impressionists themselves had been influenced by Japanese art.

Little Fauns

1909
Oil on canvas, 102.5 x 125 cm
Hermitage, St. Petersburg

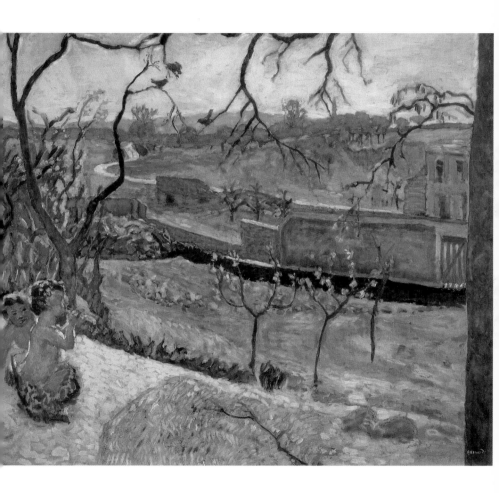

A painter of the city, Bonnard undoubtedly owed a debt to Hiroshige and Kiyonaga. Japanese prints were by no means a rarity in Paris when Bonnard studied at the Académie Julian and the Ecole des Beaux-Arts. One exhibition of Japanese art was held at the Ecole itself in 1890 and there can be little doubt that Bonnard was among its most frequent visitors. Japanese prints were cheap enough for Bonnard and his companions to be able to buy the odd one.

Train and Fishing Boats

1909
Oil on canvas, 77 x 108 cm
Hermitage, St. Petersburg

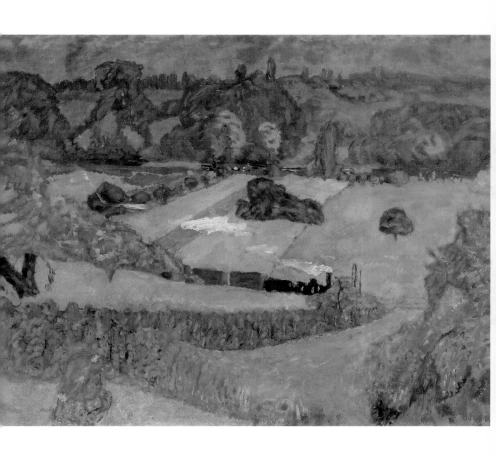

Naturally, these were the latest impressions which differed considerably from the originals. In his old age Matisse would recall: "I knew the Japanese only from copies and prints of poor quality which could be bought in the Rue de Seine by the entrance of the shops selling engravings. Bonnard said that he did the same and added that he was rather disappointed when he saw the originals. This may be explained by foxiness and faded colours of the early print-runs. Perhaps if we had seen the originals first, we would not have been as impressed as by the later prints."

Reflection in the Mirror

1909
Oil on canvas, 73 x 84.5 cm
Private collection, Switzerland

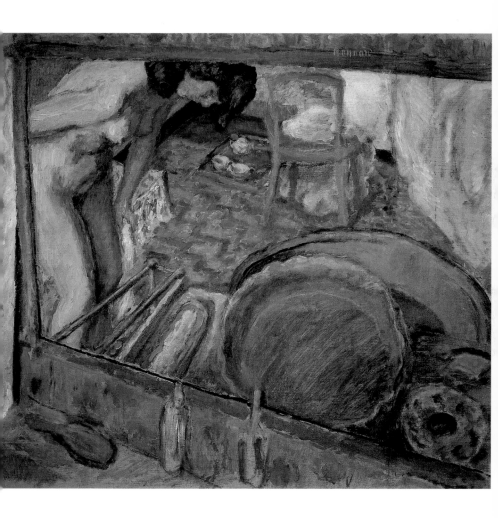

"When I came upon these somewhat crude popular pictures," Bonnard said, "I realised that colour could express anything without resort to relief or modelling. It seemed to me that one could render light, shape, typical properties by colour alone, dispensing with values." In order to understand Bonnard's first creative endeavours, it is essential to know that he, like the other members of the Nabi group, considered Japanese prints to be examples of folk art.

Poppies on the Balcony

1910
Oil on canvas, 51 x 43 cm
Musée d'Art Moderne, Troyes

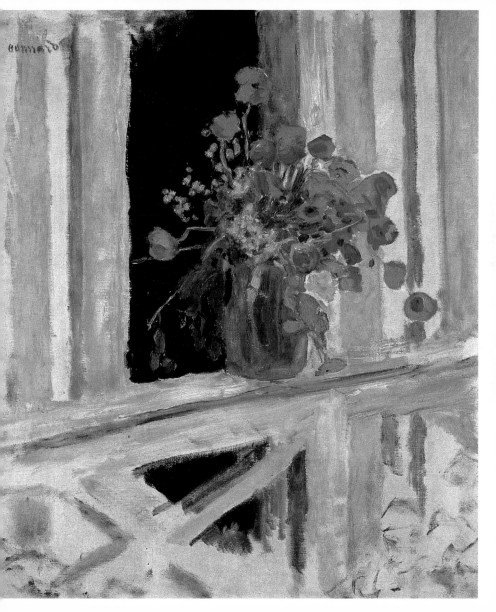

At that time, he thought of creating not masterpieces for museums but popular art suitable for reproduction; in other words, something that was to an extent mass art. "During that period I myself shared the opinion that artists should produce works which the general public could afford and which would be of use in everyday life: prints, furniture, fans, screens and so on." Only a few of Bonnard's undertakings in the field of applied arts actually came to fruition.

Bouillabaisse

c. 1910
62 x 52 cm
Location unknown

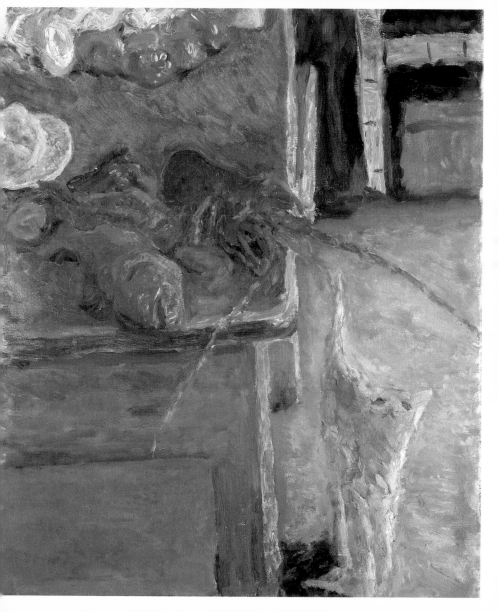

Among them was a stained-glass panel called *Motherhood,* which Tiffany's made several screens of from his cartoon, some of them painted, others decorated with colour lithographs. These screens and the design for a small cupboard with figures of two frisky dogs — probably Bonnard's only attempt to try his hand at furniture — clearly reveal a Japanese influence. Japanese prototypes are also in evidence in Bonnard's lithographs. Even his earliest print *A Family Scene* (1893) immediately brings to mind Utamaro, Sharaku and Kunisada.

The Seine at Vernonnet

c. 1910
Oil on canvas, 51 x 60.5 cm
Pushkin Museum of Fine Arts, Moscow

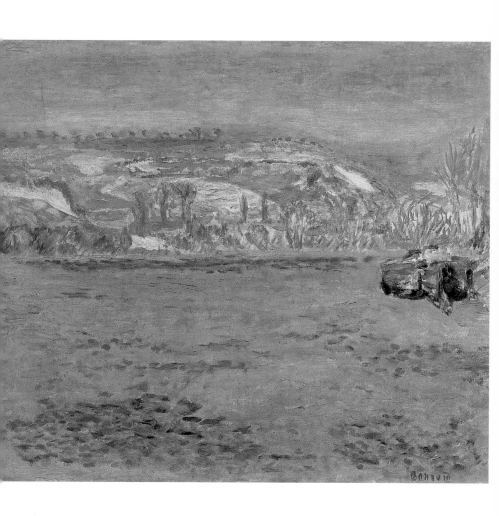

Bonnard

The works of these Japanese artists taught Bonnard the kind of stark simplicity and refinement that he could never have acquired at the Ecole des Beaux-Arts. Above all, they taught him to abandon the ideas of perspective, he had been taught to be bold in composition, to build up his picture as an arrangement of flat silhouettes, to appreciate the expressive power of a generalized patch of colour, at times unexpectedly giving close-up views and at times, on the contrary, arranging the composition in a frieze-like manner.

Woman with Parrot

1910
Oil on canvas, 104 x 122 cm
Private collection

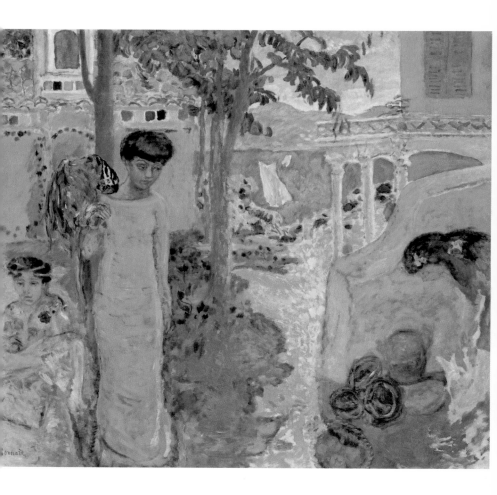

The free and at the same time energetic use of colour in Japanese woodcuts also brought Europe a great deal in both graphic art and painting. "As for painting," Bonnard wrote to Suares, "I learned a lot working in colour lithography. You discover a great deal when you explore the relationship between different tones, with only four or five colours at your disposal, placing them next to or over one another." Incidentally, even before Bonnard turned to lithography, he tried to make do with a limited number of colours, applying them in a flat manner.

The Red Chequered Tablecloth

1910
Oil on canvas, 83 x 85 cm
Private collection, Switzerland

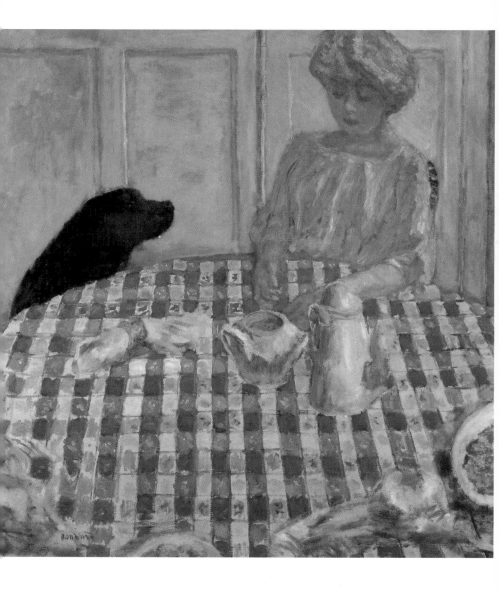

The most telling example of this practice is *The Parade Ground* (1890, private collection, Paris). It would be hard to find a small painting in the battle genre to match this picture for richness of colour and decorativeness, although the work both belongs to and, with its Japanese features, parodies the genre.

With time the colours in Bonnard's paintings became more and more subdued. To some extent this was probably due to his work in lithography.

The Seine near Vernon

c. 1911
Oil on canvas, 41.5 x 52 cm
Hermitage, St. Petersburg

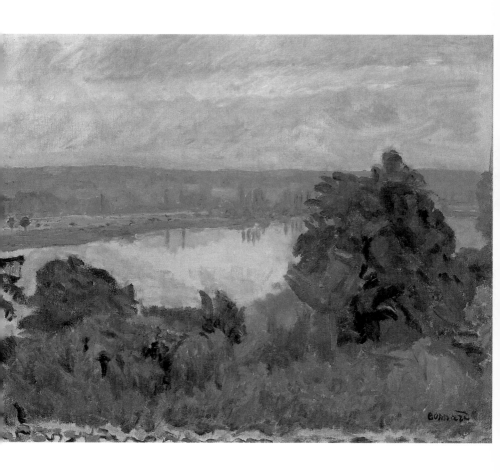

By the middle of the 1890s the artist obviously began to prefer colour combinations in which grey and brown tones predominated. Vuillard was moving in the same direction.

A typical example of this manner is Bonnard's *Behind the Fence* (1895, Hermitage, St Petersburg). What is particularly interesting about this picture? It does not depict an amusing incident; the fine draughtsmanship is absent.

Morning in Paris

———————

1911
Oil on canvas, 76.5 x 122 cm
Hermitage, St. Petersburg

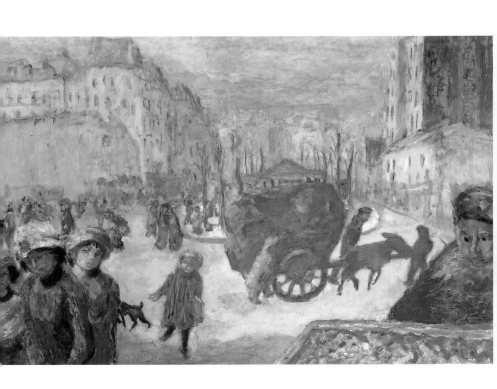

We see some very ordinary brown-coloured houses, dark winter tree-trunks, and a monotonous fence running across the whole composition. The viewer does not immediately notice behind this fence the solitary figure of a woman, who for some unknown reason has come out into the cold. Only the white splotches of snow which has just fallen and is already beginning to melt enliven a scene that does not catch the eye at all. Has this woman come out to call inside a child still playing in the gathering twilight? Perhaps.

Evening in Paris

1911
Oil on canvas, 76 x 121 cm
Hermitage, St. Petersburg

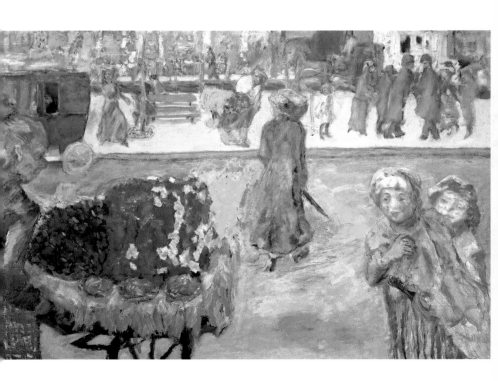

She is not dressed to go far in such weather. But all these thoughts are unlikely to enter the viewer's mind. The painting is too generalised to enable us to read something in the woman's face. The main thing is, however, that the artist does assert that the scene he presents has some kind of narrative to it. It is just an unassuming corner in the outskirts of Paris made beautiful by the subdued colouring of the picture, with its shimmering grey tones.

Although Bonnard's painting lacks bright colour accents, it is nevertheless highly decorative. This effect is primarily achieved by the fence with its diagonal lines.

The Successful Outcome

1911
Oil on canvas, 53.5 x 52.5 cm
Private collection

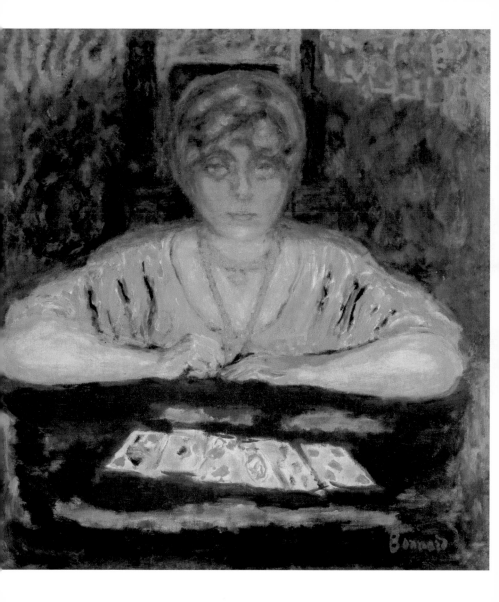

As early as the 1890s the artist was fond of compositions where prominence was given to grids of lines crossing at right angles. Usually this is seen in a woman's dress, sometimes in a scarf (let us recall that Natanson specially noted Bonnard's love of check fabrics). The artist's innate talent as a decorator revealed itself above all in the way he carefully managed tension in a picture, skilfully alternating active, checked areas with calm, empty spaces. Art historians often look on the use of checked areas in Bonnard's early work as an extreme manifestation of his Japanism.

The Terrace at Grasse

1912
125 x 134 cm
Location unknown

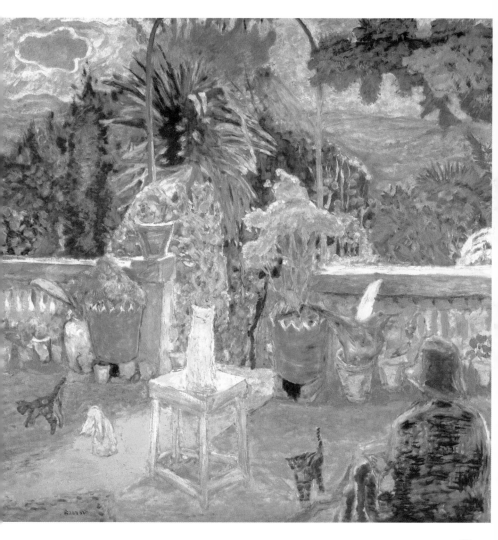

We can, indeed, find something similar in Japanese prints, but the artist did not invent ornaments, rather he was stimulated when in the real world he came across the things he liked. (His sister Andrée also loved check fabrics: the pattern of her tartan dress, in which blue and red predominated, determines the main colour characteristics of a whole painting.) There should be no doubt that the very ordinary fence depicted in the picture *Behind the Fence* really existed. "You know, there is nothing in Bonnard's work that has not come from observation," Natanson noted.

Early Spring in the Countryside

1912
Oil on canvas, 365 x 347 cm
Pushkin Museum of Fine Arts, Moscow

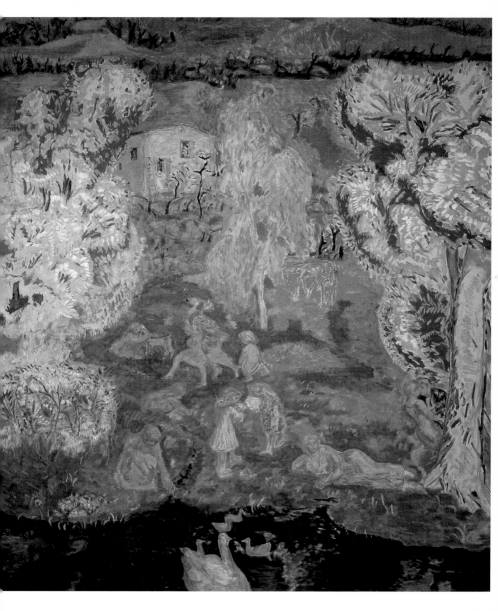

The middle of the 1890s saw a gradual change in Bonnard's art. Having begun as a convinced Post-Impressionist he now moved closer to the Impressionists, above all to Degas. In 1894 he painted a series of pictures devoted to horse-racing; in 1896 he turned to scenes in cafés and portrayed ballet-dancers; in 1897 he produced several circus scenes. The influence of Degas is evident in all these works. Bonnard did not reject the conventions of Japanese art, but adapted them to serve his own purposes: in his increasingly more realistic approach to the object of representation, and in his rendering of light, air and the depth of

Summer. The Dance

1912
Oil on canvas, 202 x 254 cm
Pushkin Museum of Fine Arts, Moscow

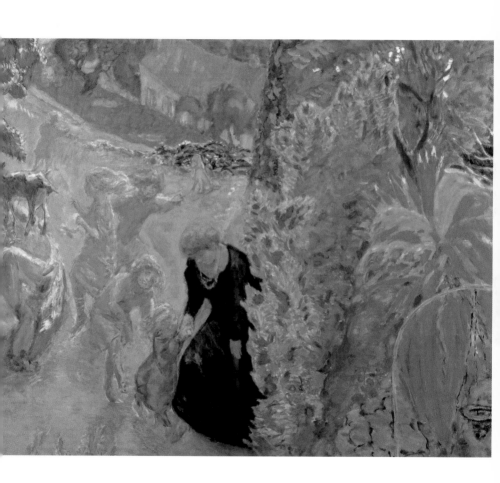

Pissarro, who had expressed dissatisfaction with Bonnard's early work, now voiced a different opinion in a letter to his son. In 1898 Bonnard received a letter from Renoir following the publication of Peter Nansen's novel *Marie*. Renoir expressed his admiration for Bonnard's illustrations for the book: "You possess the gift of charming. Do not neglect it. You will come across more powerful painters, but your gift is precious." When staying in the south, Bonnard made a point of visiting Cagnes to call on the old master.

Summer in Normandy

1912
Oil on canvas, 114 x 128 cm
Pushkin Museum of Fine Arts, Moscow

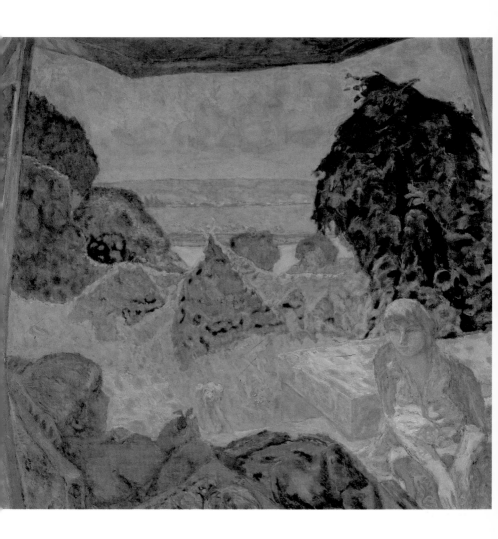

The little painting with a dedication, which Renoir gave him, was Bonnard's pride and one of his most cherished possessions. When Bonnard moved to Vernon, he struck up a closer acquaintance with Claude Monet who lived in Giverny only a few miles away. Bonnard went to Giverny to enjoy Monet's beautiful garden, to look at the landscapes with water lilies on which the leader of the Impressionists was then working, and to see again the canvases by Delacroix, Corot, Cézanne and Renoir in his collection.

Place Clichy
————————

1912
Oil on canvas, 139 x 205 cm
Musée des Beaux-Arts et d'Archéologie,
Besançon, gift of Georges and Adèle Besson

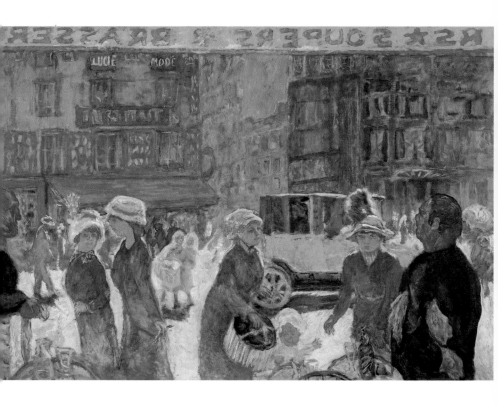

From time to time Monet's car drove up to Bonnard's house, which was called "Ma Roulotte" (my gipsy-wagon). Monet wanted to see Bonnard's latest work. They spoke little, but Bonnard was content with a smile or an encouraging gesture from Monet. Bonnard continued seeing Monet and Renoir in later years, long after these two very discriminating elder masters had recognised their younger colleague as a painter of considerable standing. At the turn of the century Bonnard seems to have been at a crossroads.

Autumn. The Grape Harvest

1912
Oil on canvas, 365 x 347 cm
Pushkin Museum of Fine Arts, Moscow

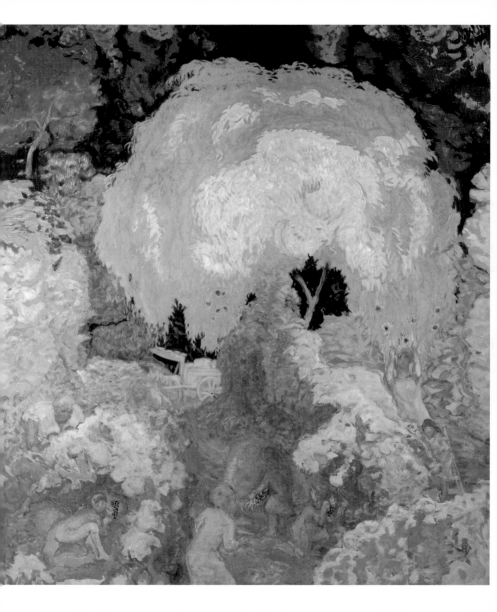

He might have continued his experiments in decorative painting. He might have concentrated his attention on an ironical and psychological approach to the subject, not unlike that of Toulouse-Lautrec. (His *Terrasse Family* provides an excellent example of his capacity in that direction.) He might have yielded to the temptations of sensual subjects exemplified by the series of nudes he painted in 1899-1900. He might have focused on portraiture: his few efforts in that line reveal him as an astute student of the human soul.

The Dressing Table and Mirror

1913
Oil on canvas, 125 x 110 cm
Museum of Fine Arts, Houston,
John A. and Audrey Jones Beck collection

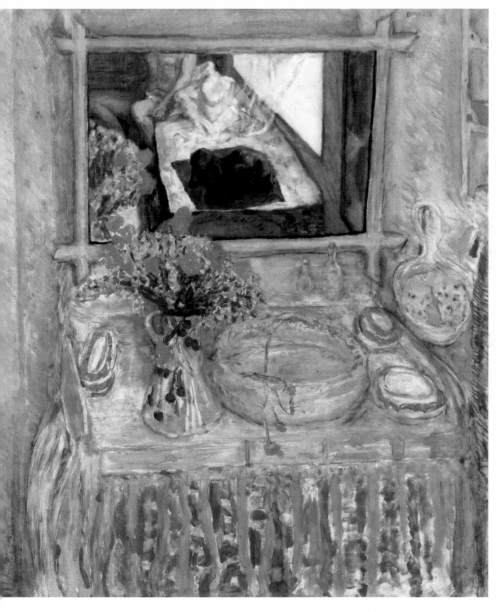

In fact, however, most of the works he created at that time and in the following decade show no marked preference for any one of these traditional genres. Nor do they show any extreme tendency in the treatment of the motif, whether decorative, naturalistic or psychological. Later Bonnard would write to the art critic Georges Besson: "I am drifting between the intimate and the decorative." Only a small number of Bonnard's works produced in the 1880's-1900's may be unreservedly classified as belonging to one particular genre: portrait, nude or landscape.

Evening

———

1914
Oil on canvas, 84 x 113 cm
Musée des Beaux-Arts, Berne

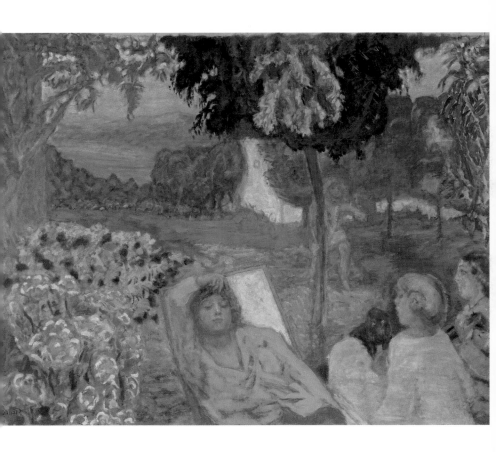

His landscapes, for instance, generally contain people who are as important a part of the picture as the surrounding scenery. Looking at his townscapes one tends to wonder what attracted the artist more — the Parisian streets or their colourful crowds. In the majority of cases Bonnard does not single out either. The artist treats the streets with their specifically Parisian hustle and bustle and wealth of colour as a mixture of landscape and genre scene forming a single whole. With Bonnard's indoor scenes, we seem to face the same question.

The Earthly Paradise

1916-1920
Oil on canvas, 130 x 160 cm
The Art Institute of Chicago

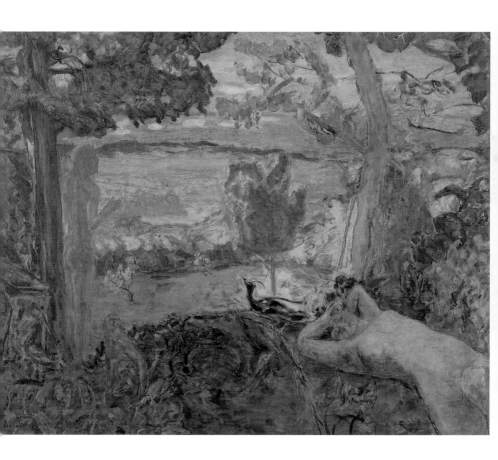

It is far from easy to decide whether we are looking at a depiction of a room enlivened by the presence of a human figure, or a genre scene where the interior serves as a background. It was, in fact, quite natural for Bonnard to combine several genres in one picture. An excellent example of this is his *Mirror in the Dressing-Room* (Pushkin Museum of Fine Arts, Moscow). The painting is considered a still life, but the elements of interior, portrait and nude are stronger than they should be in that case.

The Mantelpiece

1916
Oil on canvas, 81 x 111 cm
Marholine collection

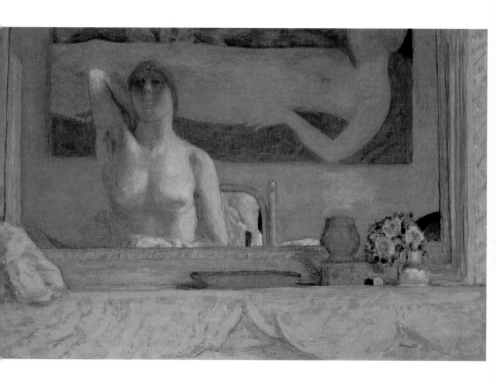

This places the work in a class of its own among European painting of the early twentieth century. During this period Bonnard drew noticeably closer to the Impressionists. In their works, particularly in Degas', he found numerous examples of an unorthodox attitude to genres. His affinity with the Impressionists expressed itself in the fact that landscape, which always predominated in Impressionist art, became an ever more important element of his painting. Moreover, it is also important to note that in his landscapes Bonnard no longer strove after decorative effect, at least that was no longer his main objective.

Summer

———

1917
Oil on canvas, 260 x 340 cm
Fondation Maeght, Saint-Paul-de-Vence

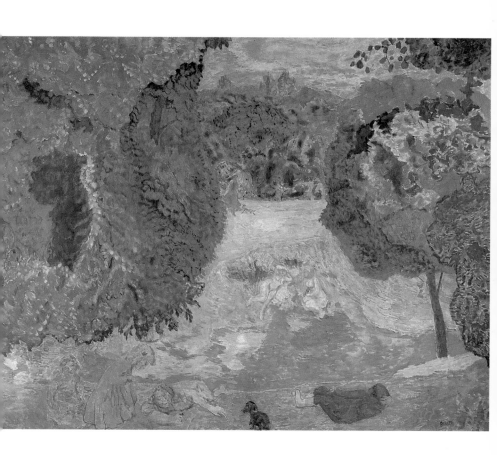

His *Landscape in the Dauphiné* in the Hermitage resembles a casual Impressionistic-style "snapshot view". The composition does not appear to follow a preconceived scheme and it is easy to imagine how it continues on either side. The painting has none of the earlier flatness; the eye is led far into the distance. The landscape, however, lacks the Impressionist luminosity. Unlike the Impressionists for whom light was of paramount importance, Bonnard valued colour above all. The *Landscape in the Dauphiné* does not attract attention immediately.

Wild Flowers

———————

1919
Oil on canvas, 55 x 49 cm
Private collection

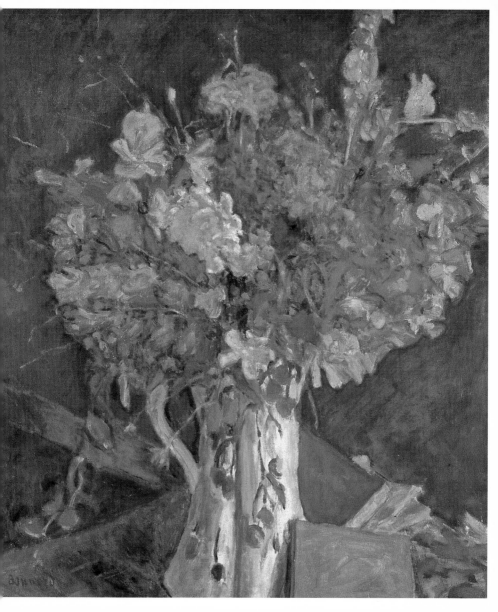

It takes time to appreciate the modest beauty of the rather dirty green colours. Bonnard managed to catch the hues of the somewhat prosaic Dauphiné countryside, seen, as it were, through the eyes of a peasant. That is not to say that the treatment of the subject reflects the usual aesthetic tastes of peasants, who would probably not like the landscape. It is more the psychological aspect, a specific sense of place. To some degree, at least, Bonnard perceives the world as it is seen by his characters themselves — in the case of this painting, by peasants working in the fields on a rainy autumn day.

The Rape of Europe
────────────────────

1919
Oil on canvas, 118 x 154 cm
The Toledo Museum of Art, Ohio, USA

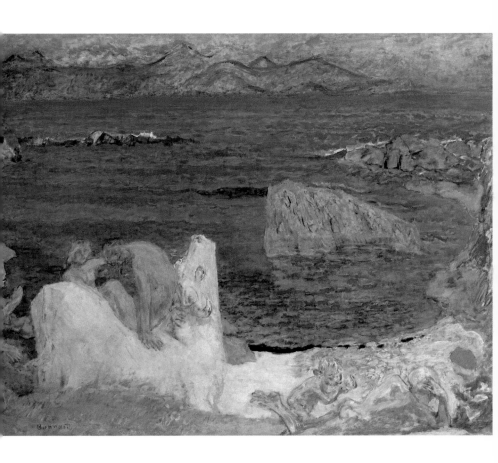

Another illustration of Bonnard's ability to look at whatever he is depicting through the eyes of his characters is his townscape *A Corner of Paris*. In the centre of the composition is a small group of children out for a walk. The ingenuous curiosity and wonder with which they see the surrounding world is echoed by the bright posters pasted on a large board. The humorous notes discernible in paintings like *A Corner of Paris* are absent in the landscapes containing no human figures, such as the two paintings of the Seine near Vernon, one in Moscow, the other in St Petersburg.

The Bowl of Milk

c. 1919
Oil on canvas, 116.2 x 121.6 cm
Tate Gallery, London

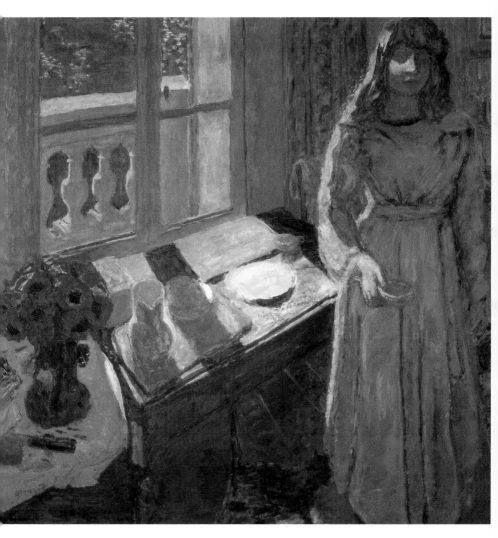

It is noteworthy that landscapes of this type are both more lyrical and less decorative. In general, Bonnard's works are usually more decorative when they contain human figures. It was when Bonnard was working on his *Corner of Paris* that the Fauves caught the public eye. Bonnard's paintings were less bright than the works of the Impressionists; next to the garish creations of the Fauves, constructed on a rolling crescendo of colours, they looked utterly faded, even timid.

Strawberries in a Cup

1920
Oil on canvas, 27 x 25 cm
The Phillips Collection, Washington

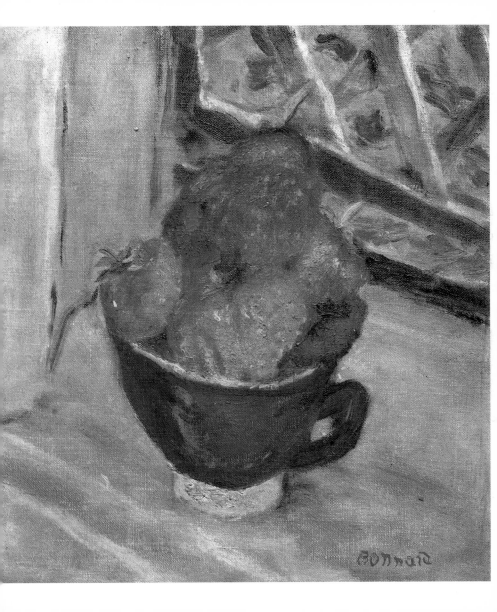

This impression was, of course, deceptive, and Matisse, the leader of the Fauves, was well aware of this. But the public and even the critics found it difficult to discern the quiet melody of Bonnard's painting among the deafening trumpets of the Fauves. It would be wrong to suggest that Bonnard was not influenced at all by Henri Matisse and his friends. The Parisian series he produced for Ivan Morozov in 1911 was painted in more vivid colours than *A Corner of Paris*.

Self-Portrait with a Beard

c. 1920
Oil on canvas, mounted on board, 28 x 44.5 cm
Private collection, London

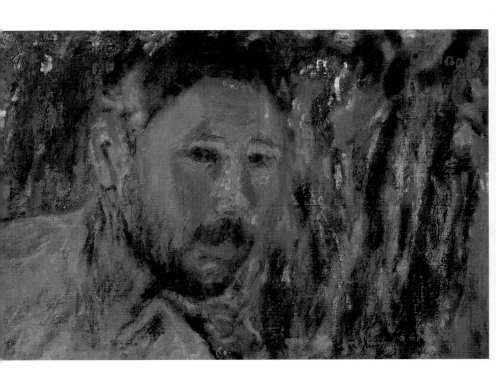

But Bonnard could never have become a follower of Matisse: his temperament and the circumstances of his artistic development, very different from those of the Fauves, precluded that. It was not only Bonnard's tendency to approach his subject intimately that made him reject the scarcity of artistic means to which Matisse and Picasso had come in the first decade of the twentieth century and which had brought them world-wide recognition as the trend-setters in contemporary art.

Josse Bernheim-Jeune
and Gaston Bernheim de Villiers

1920
Oil on canvas, 165.5 x 155.5 cm
Musée d'Orsay, Paris

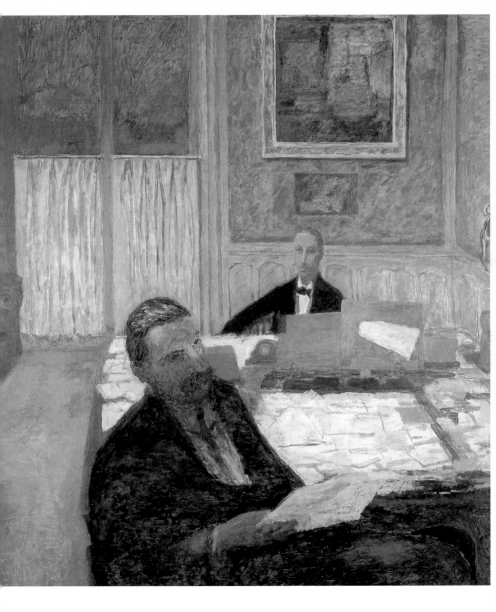

Bonnard did not consider Impressionism entirely passé, yet he wrote, "When my friends and I decided to follow the Impressionists, attempting to develop their achievements, we strove to overcome their *naturalistic conception* of colour. Art is not copying nature. We were more mindful of composition. We felt that colour should be used more effectively as a means of expression. But artistic development had gained such momentum that society was ripe to accept Cubism and Surrealism long before we had achieved our goal. We found ourselves in an uncertain position."

Pastoral Symphony

1916-1920
Oil on canvas, 130 x 160 cm
Private collection

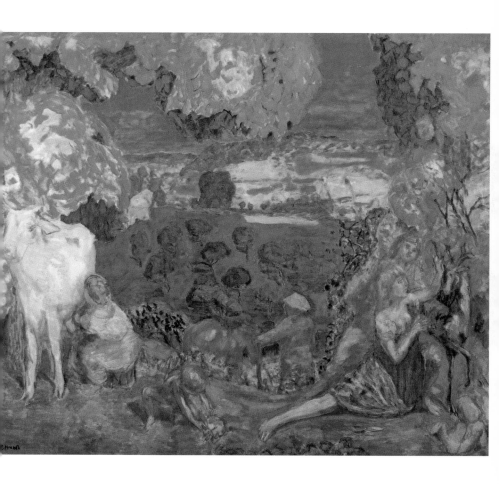

It is hardly surprising that at the beginning of the twentieth century the young artists who joined the avant-garde considered the work of Bonnard and other artists of his circle rather old-fashioned and dull. They were completely overwhelmed by Matisse's *Red Room* and *The Dance* and by Picasso's Cubist experiments. Bonnard's *Mirror in the Dressing-Room* was painted at the time when Matisse and Picasso were creating some of their famous still lifes, including Picasso's *Composition with a Skull,* now in the Hermitage collection, and Matisse's *Red Room,* which is halfway to being a still life.

Balcony at Veronnet

1920
Oil on canvas, 100 x 78 cm
Musée des Beaux-Arts, Brest

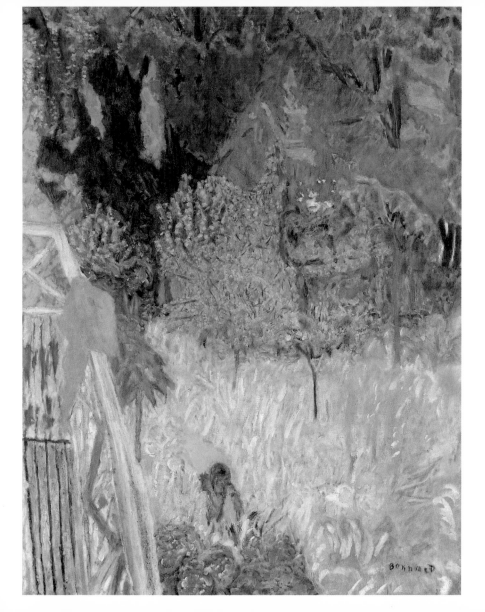

Comparing all these works, one is bound to appreciate Matisse's and Picasso's unusual boldness, yet one is also sure to realise how much painting would have lost without Bonnard, already outside the mainstream of artistic development. *Mirror in the Dressing-Room* is a wonderful illustration of how Bonnard used the lessons learned from the Impressionists, and from Degas in particular. At the same time it exemplifies the complete subordination of Impressionistic elements to a deeply individual and in essence non-Impressionistic conception.

The Open-Window

1921
Oil on canvas, 118 x 96 cm
The Phillips Collection, Washington DC

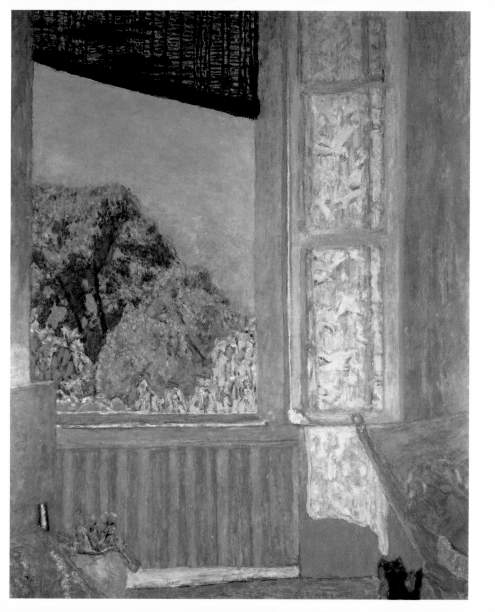

It would hardly be justified to speak here of the relationship between a pupil and his teachers. *Mirror in the Dressing-Room* clearly shows that structurally Bonnard's work was far more complicated than that of the Impressionists. Never in any of their still lifes did the Impressionists use so many motifs as well as compositional and spatial devices forming one integral whole; nor did they ever place such surprisingly diverse objects in apposition.

Landscape near Vernon

1922
Oil on canvas, 50.3 x 63.1 cm
Aberdeen Art Gallery, Scotland

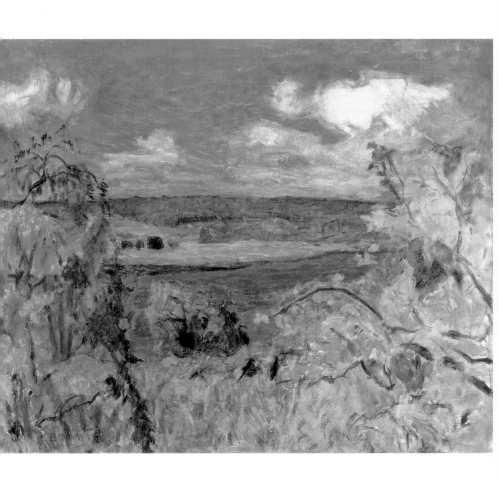

When Impressionism was in its heyday, Renoir painted an unusual still life, *A Bunch of Flowers in front of a Mirror* (1876, private collection, Paris). Looking at this fleeting vision of bright flowers, one finds it difficult to tell which of the two bunches is real; and the painter took pleasure in exploiting this effect. In Bonnard's work the mirror plays a different role. It has already been stated that no other feature reveals Bonnard's divergence from the Impressionists as clearly as his fondness for using a mirror in his compositions.

The Côte d'Azur

c. 1923
Oil on canvas, 79 x 76 cm
The Philips Collection, Washington, DC

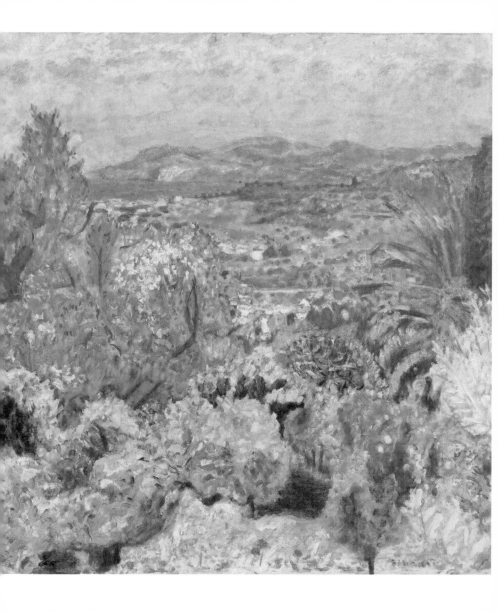

The rectangle of the mirror breaks the surface of the wall in practically the same way as an open window. Compositions containing open windows, so beloved of the Romantics, are easily understood. An open window leads the eye into the depths, giving added impetus to the view, while a mirror seems to cast the eye back into the space behind the viewer. The viewer feels himself to be not in front of the scene, but inside it. It takes some time to comprehend the relative positions of all the elements in the composition: those reflected in the mirror and thus behind the viewer,

Nude Bending Down

1923
Oil on canvas, 57.1 x 52.7 cm
Tate Gallery, London

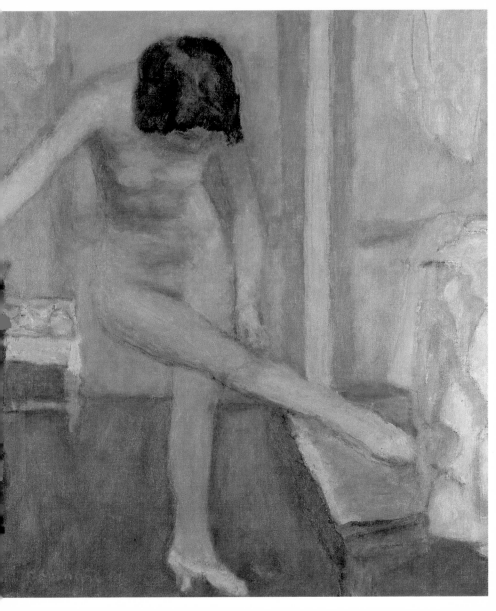

and those which are beside the mirror and hence facing the viewer. A human presence is sensed in Bonnard's still lifes even when they contain no human figure. But the most important detail of the Moscow still life is the fact that the mirror — in the centre of the composition, and also its brightest spot — reflects the model and the artist's wife unconcernedly drinking her coffee. Thus this still life does not merely represent various toilet paraphernalia, but tells the viewer something about the artist, whose studio and living-room were one and whose creative activity was more than just a job of work.

Palm Tree at Le Cannet

1924
Oil on canvas, 50 x 48 cm
Manchester City Art Galleries

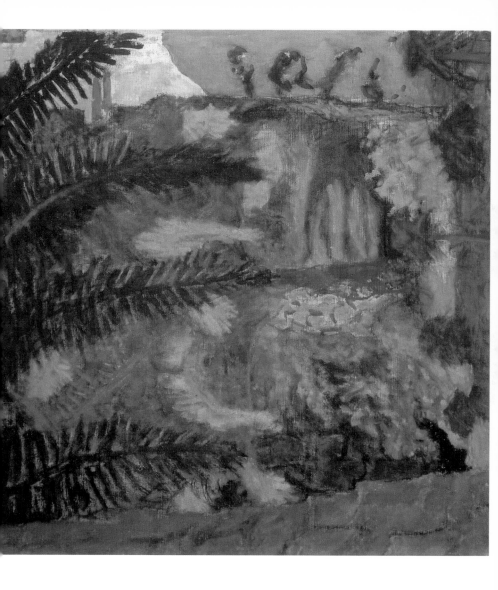

The mirror is an age-old element of the *vanitas* type of still life traditionally linked with the motif of a nude figure. Bonnard, however, did not attempt to build up an allegory. The mirror gave him an opportunity to correlate the details reflected in it (his wife Marthe, the cup in her hand, the model) with the various articles on the washstand. With this diversity of details, colour gains a special significance. Soft, muted tones predominate. On the back of the picture Bonnard wrote: "Do not varnish". The matt effect is very important in this picture.

Sailing (The Hahnloser Family)

1924
Oil on canvas, 98 x 103 cm
Private collection, Switzerland

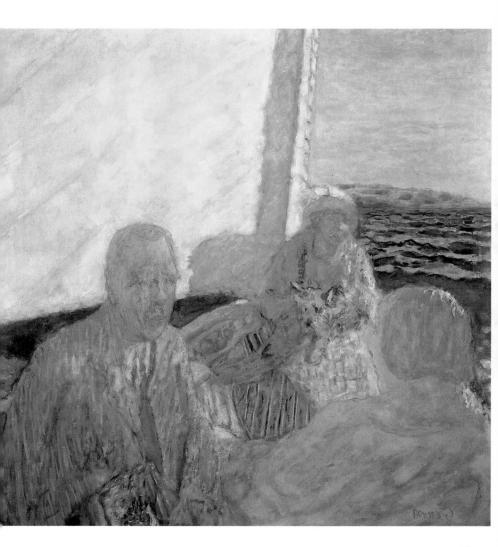

Without it the expressive range of bluish-grey tones would have lost its wonderful subtlety and richness. It is colour that ennobles articles in Bonnard's still life. Natanson recollected that Bonnard took great delight in watching reflections in a mirror as it, "like him, gave its caress to objects." The Moscow still life belongs to a series of ten pictures painted by Bonnard over a span of eight years. In the first two canvases — *Girl Drying Herself* and *The Toilette* (1907, private collection) — the most important elements are the nude figures, while the dressing-table and mirror serve merely as a background.

Nude with Right Leg Raised

1924
Oil on canvas, 74 x 78 cm
Private collection

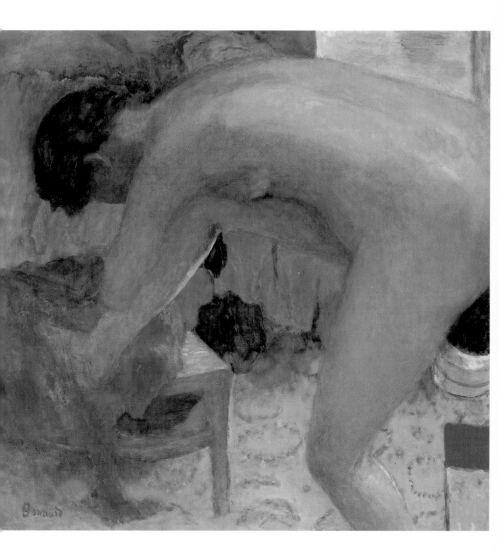

177

In the next picture, *Nude against the Light* (1908, Musées Royaux des Beaux-Arts, Brussels), Bonnard depicted a young girl looking at herself in a mirror with its "Japanese" frame already familiar from the Moscow still life, and the composition is more complicated. The painting may with equal justification be regarded as "a nude" or "an interior", since the details of the room are more than merely a background for the figure. Together with the girl, they form part of a colourful spectacle.

Pink Nude in the Bath

c. 1924
Oil on canvas, 106 x 96 cm
Private collection

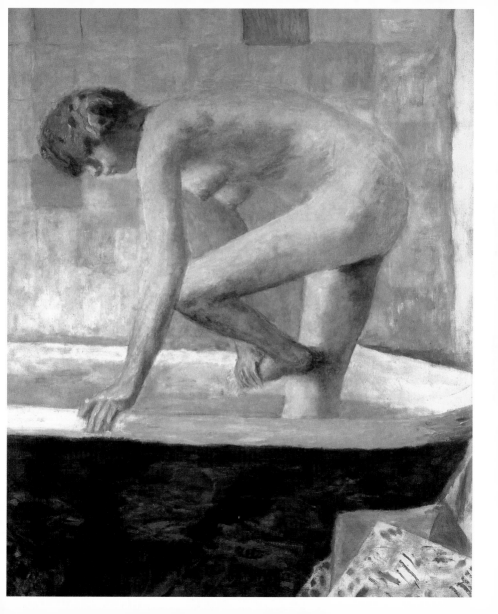

Comparing this picture with the *Mirror in the Dressing-Room*, one can understand why Bonnard painted the latter in greyish-blue colours. In *Nude against the Light* a window is seen in the middle, while in *Mirror*, where the same room is depicted, the window takes up only a narrow strip of the picture. Consequently all the objects in the first still life, the table and the wall with the mirror, are seen in backlighting. A further development along these lines may be observed in *The Toilette* (Musée d'Orsay, Paris), which may be viewed as a preliminary version of the Moscow still life.

The Large Blue Nude

1924
Oil on canvas, 101 x 73 cm
Private collection

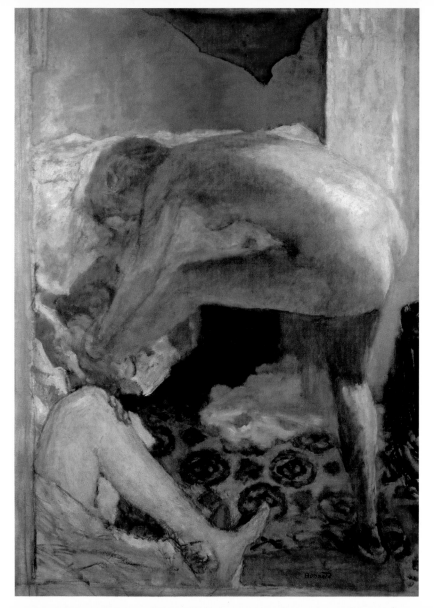

Here Bonnard draws even closer to a still life free of the former limitations of the genre. In 1909, 1913 and 1914 Bonnard again returned to the mirror motif. In the *Dressing-Table with a Bunch of Red and Yellow Flowers* (1913) the size and the basic features of the composition are the same as in the *Mirror in the Dressing-Room*, but the colour scheme determined by the inclusion of the flowers is different. The next composition, *The Toilette* (1914, Art Museum, Worcester, Massachusetts), is no longer a still life but a pure interior with the same dressing-table.

The Window

1925
Oil on canvas, 108.5 x 89 cm
Tate Gallery, London

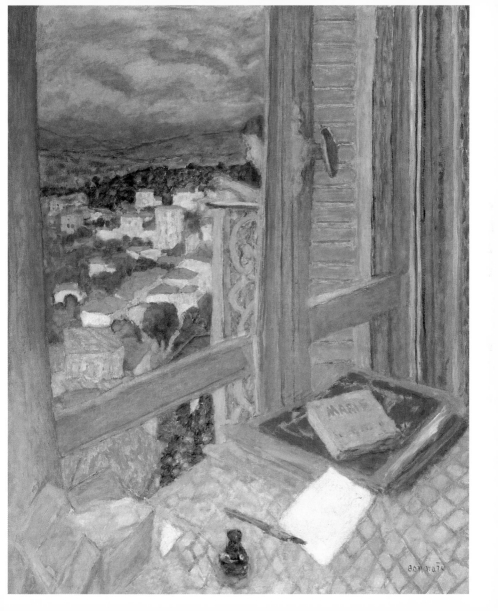

However, the window next to it has gone. Depicting objects which were always at hand or turning to outdoor scenes, Bonnard did not strive to recapture an immediate impression. As a rule, he started working on his painting only when such impressions had taken root in his mind and passed through the filter of the artist's memory. Feeling no obligation to reproduce an object of his observation precisely, he included in his pictures only that aspect of it which could be subordinated to the imperatives of art. In this way he made every area of his canvases rich in texture and colour.

The Table

—————

1925
Oil on canvas, 103 x 74.5 cm
Tate Gallery, London

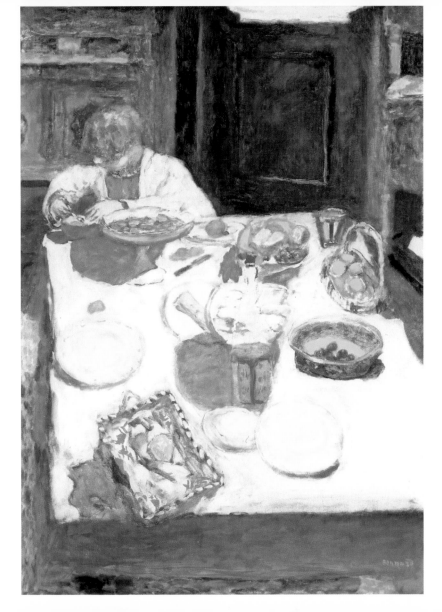

The impact Bonnard's works have on the viewer does not rest solely on his ability to reveal the most painterly aspect of an ordinary object, but also on the hidden metaphorical and universal meaning of the colours he used. For this reason Bonnard never tired of depicting the same objects, and turned again and again to the same motifs. Of course, this practice never amounted to mere repetition. His way towards revealing the beauty inherent in any object lay primarily through the rich expressive resources of colour, making a metaphorical link with what is precious.

The Bath

―――――――

1925
Oil on canvas, 86 x 120 cm
Tate Gallery, London

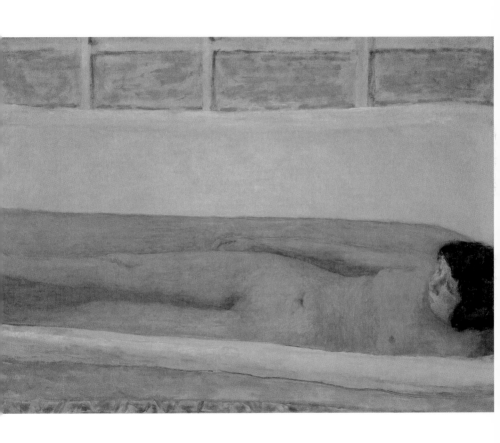

Bonnard believed that "a picture is a patchwork of colours which, when combined with each other, in the final analysis form an object in such a way as to allow the eye to glide freely over it without encountering obstacles". Bonnard delighted in walking the tight-rope between the stylised decorative abstraction and the unstylised realism. His *Landscape with a Goods Train (Train and Fishing Boats)* provides a typical example. Each detail of the landscape may puzzle the viewer. It takes time to identify the tree in the right lower corner for what it is or the vineyard on the left.

The Palm

1926
Oil on canvas, 114.3 x 147 cm
The Phillips Collection, Washington DC

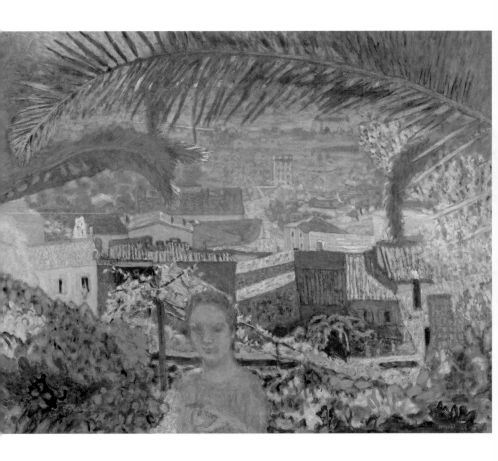

All details are governed by the ensemble of tones. That is why Bonnard is inevitably vague. It is as if he was reproducing the impression of a person walking down a path or, perhaps, looking at the scene from a moving train. For instance, it takes time to make out the fascinating figure of a little girl. This "sketchy" manner of painting is very characteristic of Bonnard. He tends to avoid a close scrutiny of his characters. Looking at the *Landscape with a Goods Train*, the viewer finds himself drawn into a system of resemblances.

Leaving the Bath

c. 1926-1930
Oil on canvas, 129 x 123 cm
Private collection, Switzerland

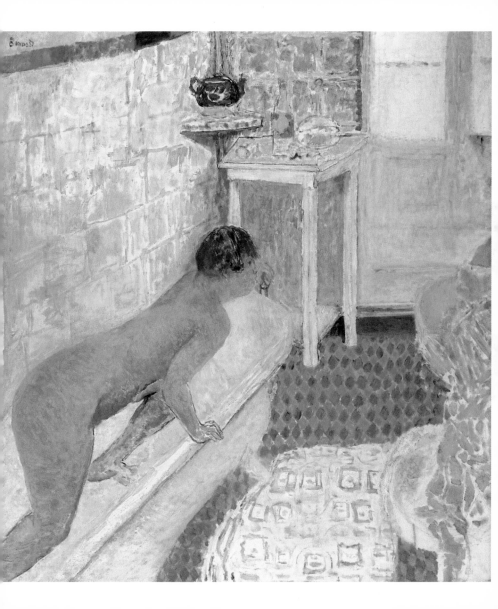

In pictorial terms, as well as by some inner meaning, the head of the little girl, the clump of trees, the puffs of smoke coming from the engine and the tugs, and the clouds are linked in a common chain. For all the relative nature of brushstrokes or, perhaps, because of it, the viewer is made to feel himself inside the picture, as in the *Mirror in the Dressing-Room*. For this reason too, the foreground is more blurred than the rest of the picture. Here, in a panoramic landscape, Bonnard retains the intimacy typical of his work.

The Large Reclining Nude

———————————————

1927
Oil on canvas, 142 x 181 cm
Private collection

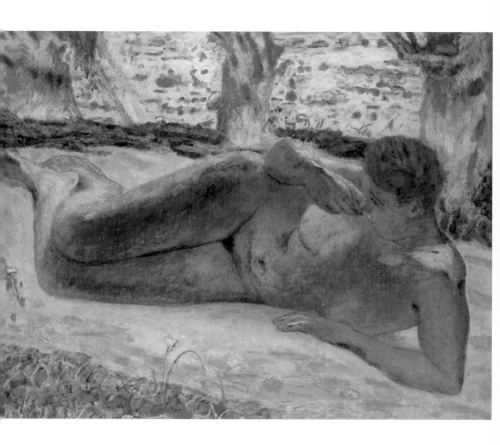

The *Landscape with a Goods Train* and *Early Spring. Little Fauns* address the viewer in the artist's usual quiet tones. They are imbued with his unique brand of lyricism and winning archness. With an ease typical of him, Bonnard introduces a group of fauns into his landscape, figures which could never have appeared in the canvases of the Impressionists. The puffed out cheeks of the faun playing the pipe is a delight. You do not immediately notice these little goat-legged creatures at the edge of the painting, but once you do, you cannot banish them from this convincingly real corner of the Ile-de-France.

The Terrace at Vernon

c. 1928
Oil on canvas, 242.5 x 309 cm
Kunnstsammlung Nordrhein-Westfalen, Düsseldorf

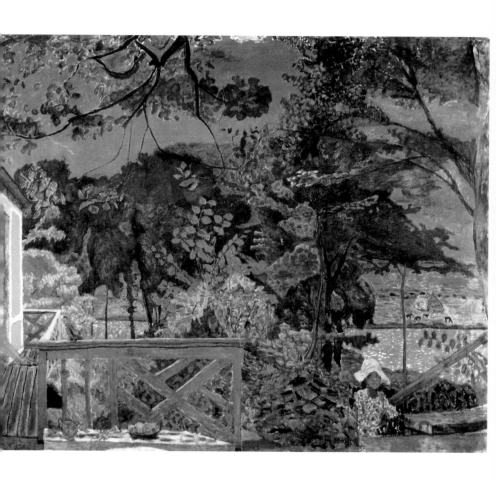

And this unpretentious, yet endearing landscape seems alive with the gentle silvery sounds of the pipe. By introducing fauns into his landscape, Bonnard endowed it with metaphorical overtones. A friend of the Symbolists, he used their poetical methods, at the same time gently mocking them. It is hard to decide what is more important in this picture, the humour or the joy at nature reawakening. It is this unity of poetic joy and gentle irony that makes the landscape of the countryside around Paris at the same time an embodiment of the mythical Golden Age.

Normandy Landscape

1920-1930
Oil on canvas, 62 x 80 cm
Northampton (Mass.), Smith College Museum of Art

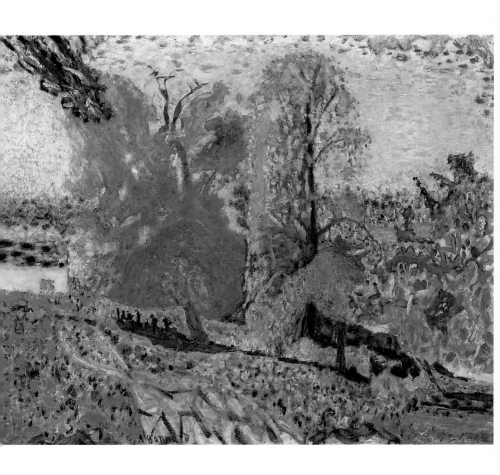

197

The nature of Bonnard's relationship with Impressionism, a key factor in his art, reveals itself most vividly in the subjects he chose and in his compositions. The Parisian townscapes may serve as an illustration. In comparison with his early pictures of Paris, the urban scenes executed in 1911-12, representing one of the peaks in Bonnard's art, are remarkable for their more complex composition. They contain more human figures, more space and more light, and they are richer in colouring. These features place them close to the works of Monet, Pissarro and Renoir.

The Breakfast Room

1930-1931
Oil on canvas, 159.6 x 113.8 cm
Museum of Modern Art, New York

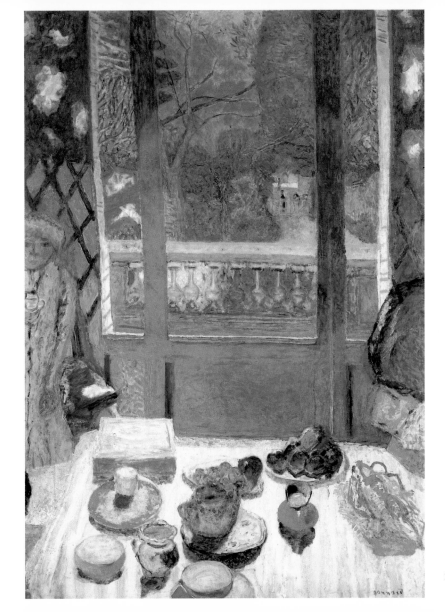

An Impressionistic flavour is strongly felt in his city scenes *Morning in Paris* and *Evening in Paris,* a pair of works painted for Ivan Morozov and seemingly bearing all the marks of a casually observed scene. In fact, of course, this was not the case. Both pictures were painted from memory, as was Bonnard's usual practice. In these two townscapes Bonnard was particularly attentive to composition and in this respect, as before, he demonstrated a closer affinity to Degas rather than to Monet and Pissarro.

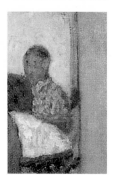

Breakfast by the Radiator

c. 1930
Oil on canvas, 74 x 84 cm
Private collection

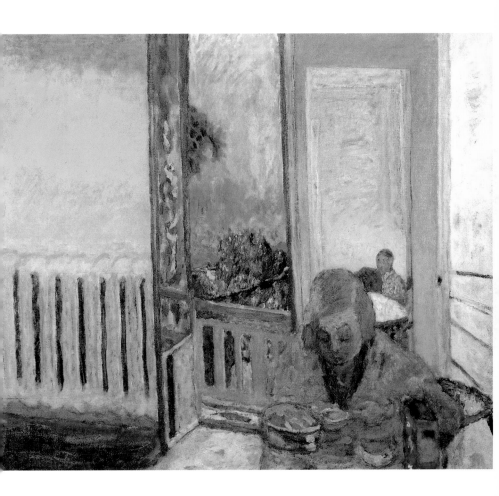

Indeed, in his very conception of street scenes, Bonnard also followed Degas, or perhaps even Caillebotte, while Monet and Pissarro, the founding fathers of the Impressionistic townscape, were absorbed with a desire to show street life, with its unceasing movement, from a distance and avoided close-up or even middle-ground views of pedestrians. Yet unlike Degas *(Place de la Concorde,* 1873, Hermitage) and still less like Caillebotte *(A Paris Street in the Rain,* 1877, Art Institute of Chicago) Bonnard does not focus on the human figures and avoids depicting them in detail.

The Provincial Pot

1930
Oil on canvas, 75.5 x 62 cm
Private collection, Switzerland

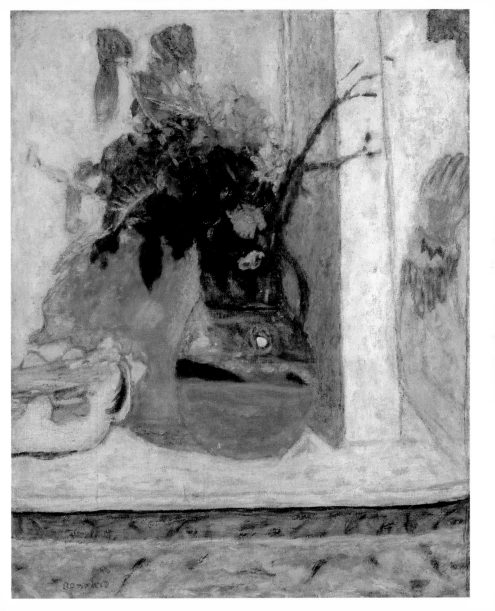

The soft, subdued patches of colour affect the viewer before he has become aware of what this or that patch actually represents. Bonnard's wonderfully orchestrated colour arrangements are not arbitrary. In *Morning in Paris,* the blue and pink tones of the sky and the cool hues of the foreground are so true to life that they alone, even without the scurrying pedestrians and the coal-merchant's cart with its early-morning load, clearly indicate the time of the day. But even after we realise the significance of the colour, that does not reduce its charm; quite the contrary, it is increased.

The Coffee Mill

1930
Oil on canvas, 48 x 57 cm
Winterthur, Kunstmuseum

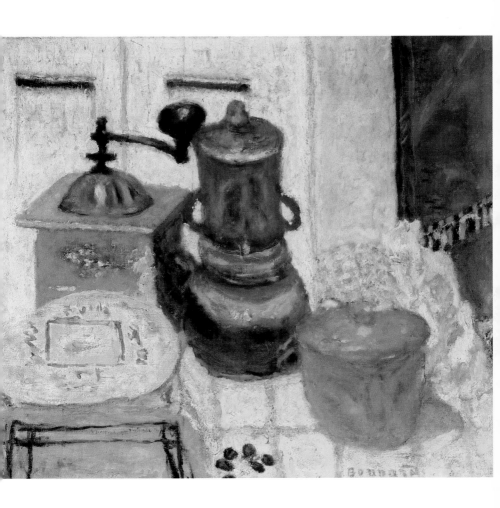

The patches of colour do no more than "name" the objects depicted. They are sufficiently autonomous, and the beauty of their combinations could serve as a powerful justification for their independent existence. At the same time, each masterly brushstroke and each patch of colour possesses a wonderfully keen and expressive force. The vagueness of Bonnard's painting does not reduce but intensifies that expressiveness. For example, the patch of colour representing a dog in *Morning in Paris* shows only its body and tail, but these details are enough to reveal the animal's behaviour with a striking liveliness and precision.

Nude in the Bath

1931
Oil on canvas, 120 x 110 cm
Musée National d'Art Moderne,
Centre Georges Pompidou, Paris

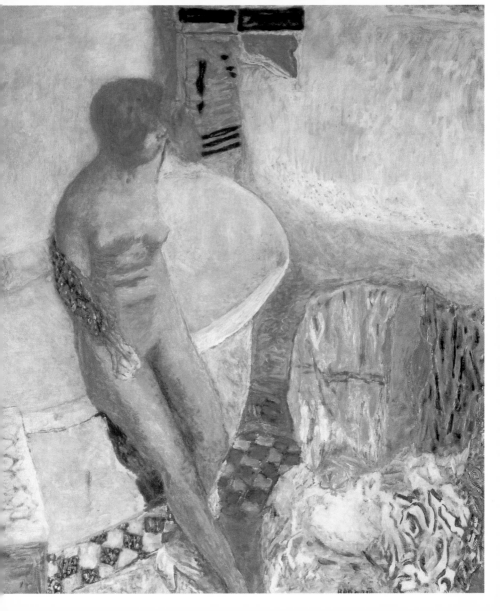

In the same picture, the silhouette of the coal-merchant's donkey heavily and hurriedly moving its slipping legs may serve as another example. There is no animal painter of modern times who understood the character of animals better than Bonnard. With the alert eye of a master, Bonnard also catches a person's way of walking or behaving. The old flower-seller in *Evening in Paris* moves in a manner typical of her alone, unhurriedly measuring each step. The children fooling about a bit in the street move as only children can.

The Boxer

1931
Oil on canvas, 54 x 74 cm
Private collection, Switzerland

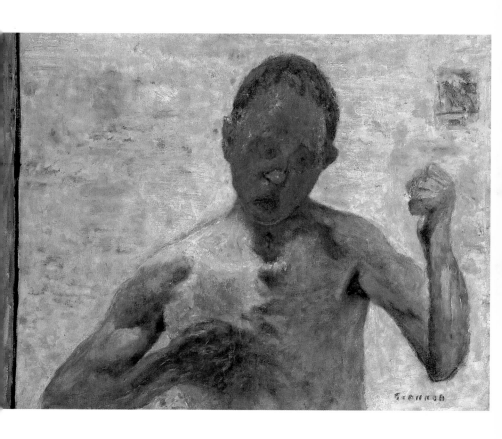

The details of the picture are arranged so as to give an impression of the Parisian way of life. In *Morning in Paris* in the foreground the artist depicts people who have to rise early — the old coal merchant, a group of young girls hurrying to work, a little boy loitering on his way to school. In *Evening in Paris* the movement of the figures is quite different. Here people are out for a stroll. In the first picture, Bonnard depicts a square, a junction of different streams of movement; in the second, a boulevard. In the first case, the artist needs an open space; in the second, a closed space.

White Interior

1932
Oil on canvas, 109 x 156.5 cm
Musée de Grenoble

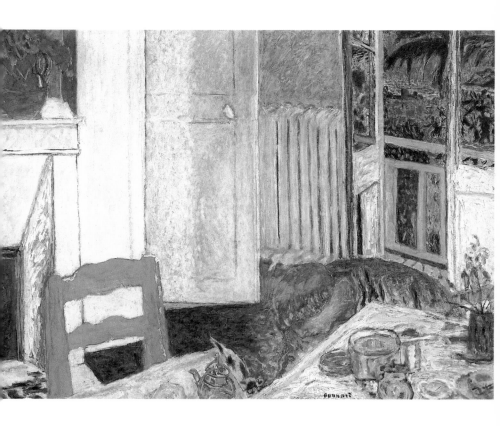

In the morning scene it is important to show the sunrise colours of the sky and the walls of houses catching the first rays of the sun; for the scene at dusk other details are necessary. "What is beautiful in nature", said Bonnard "is not always beautiful in painting, especially in reduction. One example is the effects of evening and night." They say that Felix Fénéon, the manager of the Bernheim Gallery, once casually remarked to Bonnard that his Parisian street scenes were a success after which the artist stopped painting them.

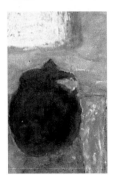

Breakfast Room in the Country

1934-1935
Oil on canvas, 127 x 135 cm
Solomon R. Guggenheim Foundation, New York

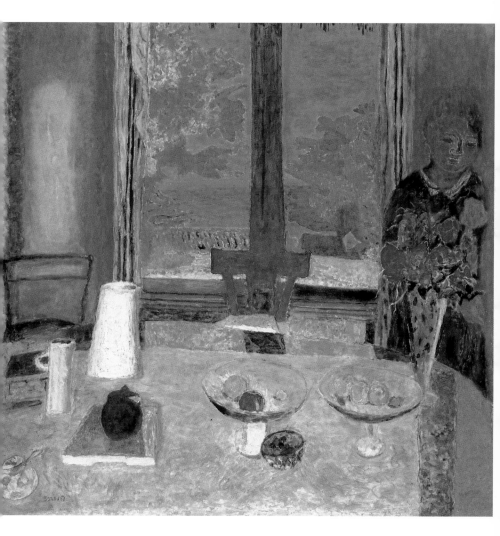

This may have taken place in 1912, when the series of works commissioned by Morozov was on display for the first time at the gallery. Bonnard was always mistrustful of success; to his mind, it made an artist repeat himself. Whatever the truth of the matter, Bonnard's last picture of this kind, *Place Clichy,* is dated 1912 (Musée des Beaux-Arts et d'Archéologie, Besançon). It is a large painting which appears to be a sort of synthesis of the motifs in the Moscow works. The liveliness, the unassuming simplicity of the subject, an apparently casual composition which, however, always has a "framework"

The Table in Front of the Window

1934-1935
Oil on canvas, 101.5 x 72.5 cm
Private collection, New York

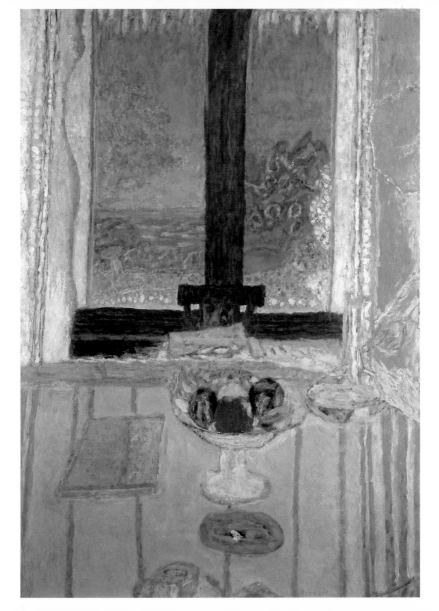

(Bonnard's word) and is well balanced, the mobility of texture, with each brushstroke vibrating in every patch of colour — all these elements are characteristic of an easel painting. It would seem from this that Bonnard had no special talent for monumental art, yet his large decorative panels are excellent. All the Nabis produced works in this field, but the most notable were by Bonnard, for his art is devoid of the deliberate solemnity nearly always present in monumental painting. Bonnard's most outstanding large work is undoubtedly the triptych entitled *Mediterranean.*

Nude Seen from the Back
at Her Toilet

1934
Oil on canvas, 105 x 73 cm
Musée National d'Art Moderne,
Centre Georges Pompidou, Paris

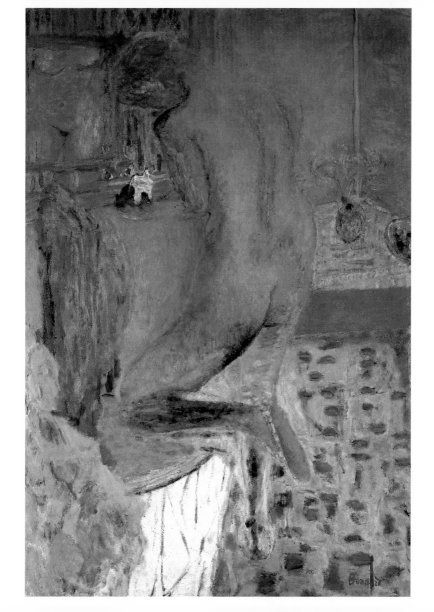

Working on large paintings, Bonnard did not invent a new style. On the whole, his manner remained the same as in his small canvases. True, in these he used simpler, clearer compositions and the overall tonality changed under the influence of the southern lighting. The artist's sincerity, his deeply personal and poetic vision of reality and his unerring feeling for colour helped him to work on large surfaces with undiminished confidence. Displaying a close affinity to the elderly Monet with his water-lilies series and his great panels for the Orangerie,

Corner of a Table

———————————

1935
Oil on canvas, 67 x 63.5 cm
Musée National d'Art Moderne,
Centre Georges Pompidou, Paris

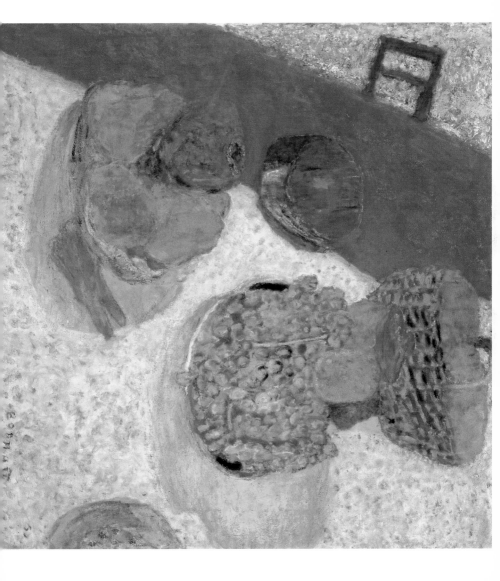

Bonnard left a noticeable mark in decorative painting, although the path thus mapped out was not followed by succeeding generations of monumental artists. The triptych forms, in fact, one picture — a landscape on three sub frames. At the same time, each canvas is compositionally complete. For this reason each panel requires space around it, "room to breathe". Bonnard knew that the staircase in Morozov's mansion for which the triptych was intended had semi-columns and he planned that they would act as spacers within the composition.

The Circus Horse

1936-1946
Oil on canvas, 94 x 118 cm
Private collection, Fontainebleau

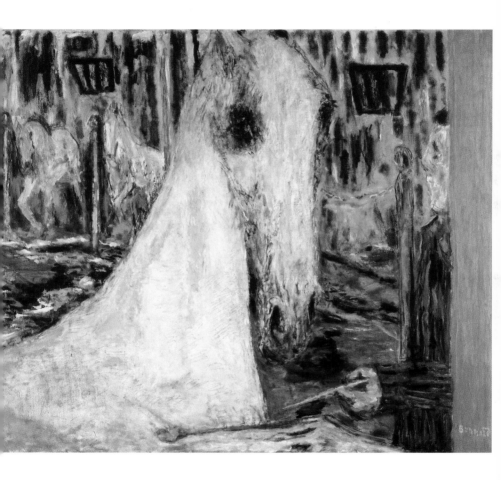

The semi-columns served both as frames and as functional elements of the scene. The subject of the triptych is a garden with a view of the Mediterranean. The garden is not empty: the central panel features an amusing group of children playing; each of the side panels includes a young woman. Although all the human figures are placed in shadow, the triptych would lose a great deal without these gently graceful, typically Bonnardian women and the funny, restless children. Yet, the landscape is more important here than the human figures, a landscape which is not wild and primordial, but cultivated,

The Garden
———————
c. 1936
Oil on canvas, 127 x 100 cm
Musée du Petit Palais, Paris

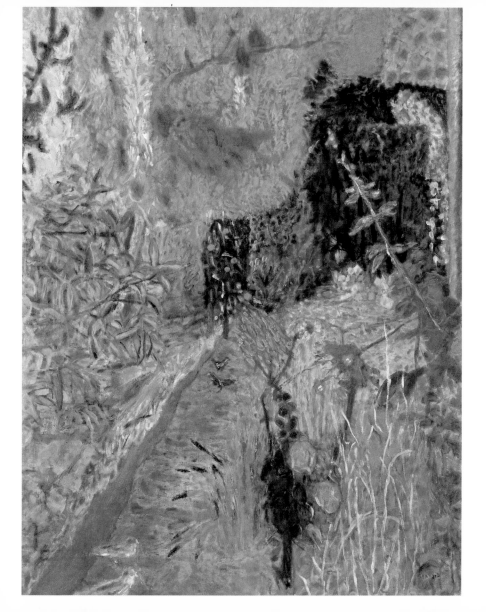

a landscape produced by hundreds of years of European civilization nurtured by the Mediterranean. A great deal of space in the garden is taken up by the trees. Their theatrical and festive arabesques set the general, decorative tone of the pictures and create a feeling of luxuriant nature. In the background, which nevertheless seems somehow close to the viewer, subordinate to the rules of flat landscape painting, is the alluring blue of the Mediterranean, the birthplace of European civilization. A comparison with *View of Saint-Tropez* (1909, Hahnloser collection, Bern),

Port Trouville

1936-1946
Oil on canvas, 77 x 103 cm
Musée National d'Art Moderne,
Centre Georges Pompidou, Paris

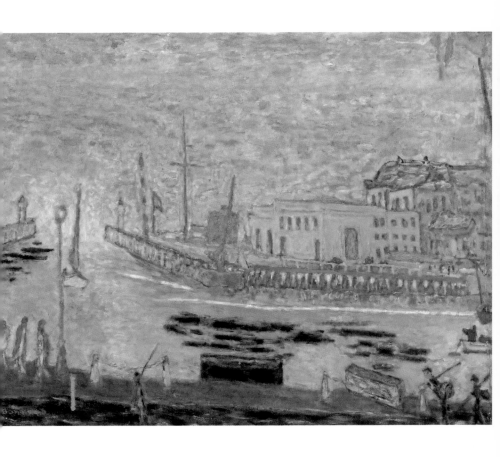

the forerunner of the central panel, shows that in the triptych Bonnard omitted the opening to the sea. This made the composition more tranquil and even majestic. It is not just a view, but an image of the Mediterranean. In this respect the triptych painted for Morozov represents a new stage in Bonnard's evolution, although the stylised treatment of the trees goes back to the artist's experiments in the l890s. When Morozov commissioned two more panels to complete the triptych, Bonnard returned to already familiar subjects: early spring and the middle of autumn.

The Pastoral

––––––––––––

1937
Oil on canvas, 335 x 350 cm
Palais de Chaillot, Paris

These two panels flanked the triptych that represented summer time, and thus formed a seasons-of-the-year ensemble. *Early Spring in the Countryside* and *Autumn. Fruit-Picking* are technically inferior to the triptych, but they complement it admirably. Though Bonnard had not visited Moscow, he had a good idea of the setting in Morozov's mansion where the works would be hung. The triptych was to decorate the main staircase, extending its vista, and for that reason had to have additional depth. The two panels ordered later were to hang on the side walls.

The Yellow Boat

1938
58 x 76 cm
Location unknown

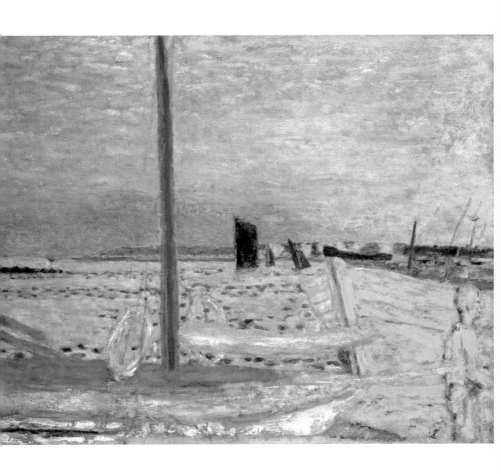

They are flatter and more restrained in colour, while the decorative treatment of the trees is reminiscent of ancient tapestries. The panels also display features linking them with oriental art. Clive Bell, an English art critic, once perspicaciously remarked that "Bonnard's pictures as a rule grow not as trees; they float as water-lilies. European pictures, as a rule, spring upwards, masonry-wise, from their foundation; the design of a picture by Bonnard, like that of many Chinese pictures and Persian textiles, seems to have been laid on the canvas as one might lay cautiously on dry grass some infinitely precious figured gauze."

Basket and Plate of Fruit
on the Chequered Tablecloth

c. 1939
Oil on canvas, 58.4 x 58.4 cm
The art Institute of Chicago,
gift of Mary and Leigh Block

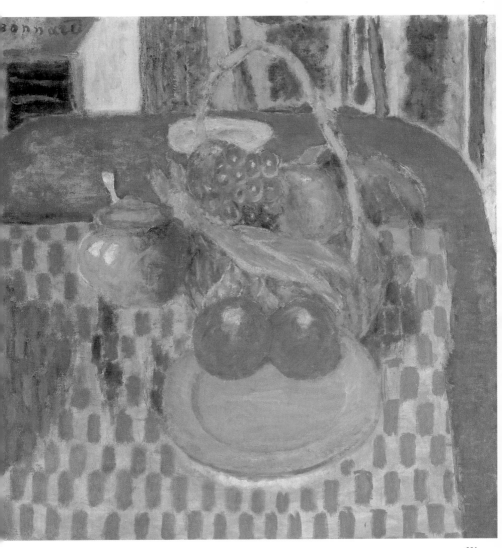

In the panels representing spring and autumn, Bonnard obviously depicted gardens in the north, a fact to which the preliminary sketches also testify. In another panel — *Summer. The Dance* — painted in the same year and to a considerable extent related to Morozov's ensemble, Bonnard depicted a southern landscape. The artist admitted that he preferred the northern light, but to the viewer the difference between the north and the south is of secondary importance. Whatever the case, he sees first and foremost Bonnard's vision of nature and only after that a definite landscape in Saint-Tropez or Vernonnet.

The Studio with Mimosa

1939-1946
Oil on canvas, 127 x 127 cm
Musée National d'Art Moderne,
Centre Georges Pompidou, Paris

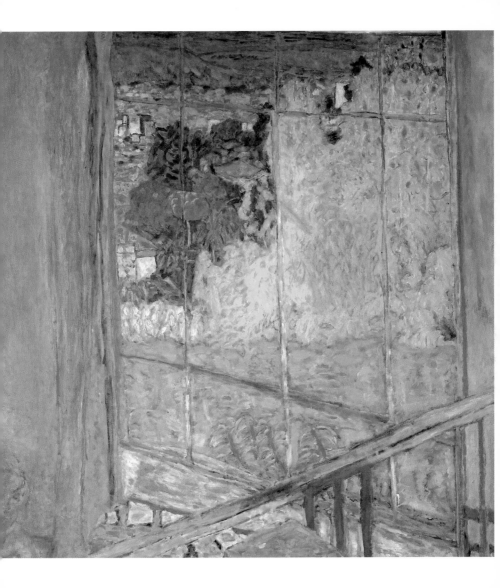

However decorative Bonnard's representation of nature is, it never becomes a mere background subordinated to the human figures. The regally transformed world of vegetation is the embodiment of Bonnard's dream, his ideal, his joy, at times masked by a humorous and, at first glance, flippant irony. However, the beautiful nature in his paintings rejects dramatic or prosaic events, didactic subjects or subjects with a pathetic tinge. But it readily admits a group of children playing or women enjoying a chance to relax. Even the fruit-picking in the panel *Autumn* reminds one of a game rather than work.

The Descent to Cannet

1940
Oil on canvas, 65 x 72 cm
Metropolitan Museum of Modern Art,
New York, Robert Lehman Collection, 1975

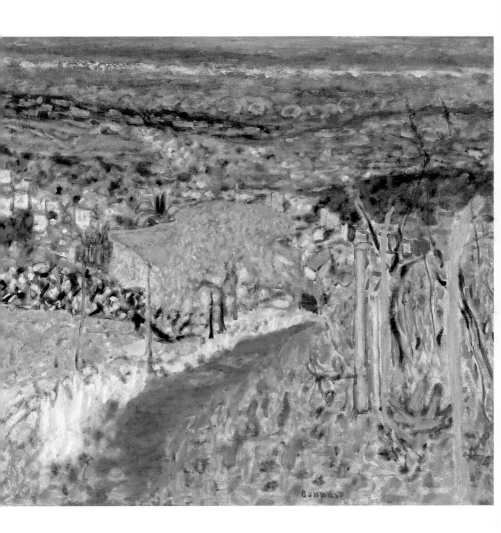

In Bonnard's pictures of nature in festive mood only isolated features remind one of the real-world prototypes. That is not to say that the artist felt no need of any original for his decorative paintings. These wonderful states of nature were not invented but observed. While painting his earthly paradise, Bonnard, however, did not feel obliged to reproduce all the details of a real scene. Depicting the landscape of Provence in *Summer. The Dance*, he introduced into it, without hesitation, a usual motif of his — the games and pranks of his sister's children, which he loved watching and even joining in.

Landscape at Le Cannet,
View Over the Rooftops

1941-1942
Oil on canvas, 80 x 104 cm
Private collection

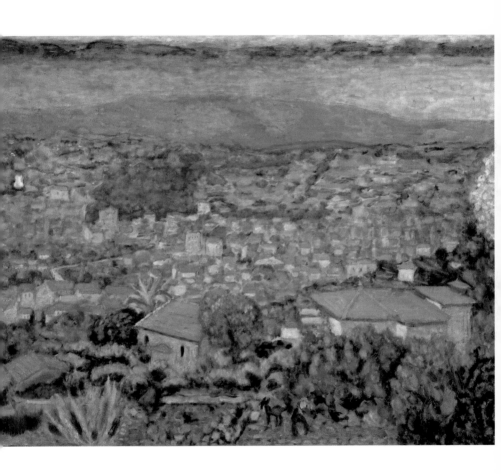

237

Of course, that did not take place in the south. The characters in the panel *Summer. The Dance* are not those depicted in the group portrait of the Terrasse family. They are imaginary, but they do make one think of their prototypes. Bonnard's fantasy, like that of any great artist, was founded on impressions from real life, and it is important to stress that on the whole these were happy, joyful impressions. In this respect Bonnard was a follower of Watteau, Fragonard and Renoir, and a fellow of his contemporaries, Matisse and Duly.

Sombre Nude

1942-1946
Oil on canvas, 81 x 55 cm
Private collection, Paris

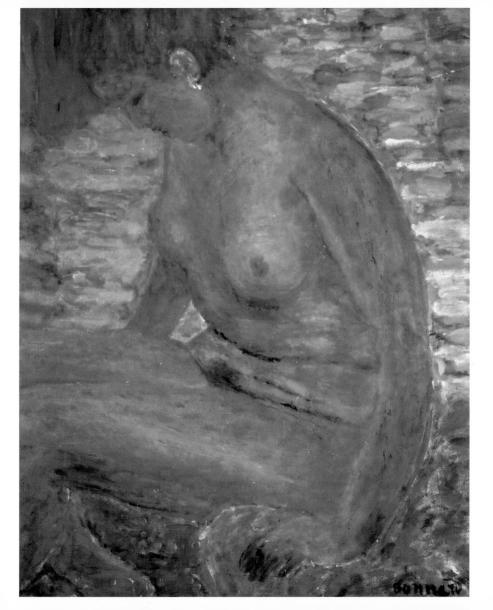

Not only in his decorative panels, but also in his easel compositions depicting open-air scenes, Bonnard sacrificed the anthropocentrism deeply rooted in European art, to the joyous, happy world he created. An excellent example of this is provided by the Moscow picture *Summer in Normandy.* Here nothing has been invented. The work shows two women having a chat on the terrace of the villa "Ma Roulotte" in Vernonnet. The one on the left is the artist's wife. The dog, Ubu, always nearby, is looking up at them from below with an expectation typical of dogs.

Self-Portrait

———————

1945
Oil on canvas, 56 x 46 cm
Private collection, USA

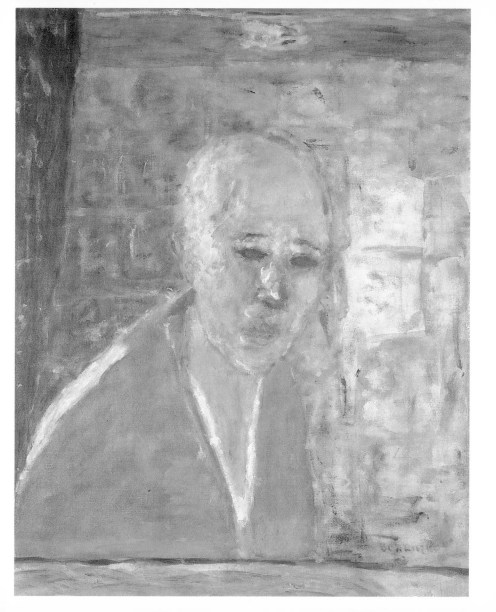

In the background, the Seine glistens behind the trees. Although the two women are in the foreground, you do not notice them at once. The viewer's attention is attracted primarily to the garden and the fields in the background, since Marthe's figure is placed in the shadow, while that of her friend, who is sitting in the sun, is masked by a green dress. But even when you notice the women, you perceive them as an integral part of this wonderful corner of nature. There is nothing in this picture of the role formerly played by landscape — as a background for a human figure depicted in the foreground and thus inevitably dominant.

Self-Portrait in the Mirror

1945
Oil on canvas, 73 x 51 cm
Musée National d'Art Moderne,
Centre Georges Pompidou, Paris

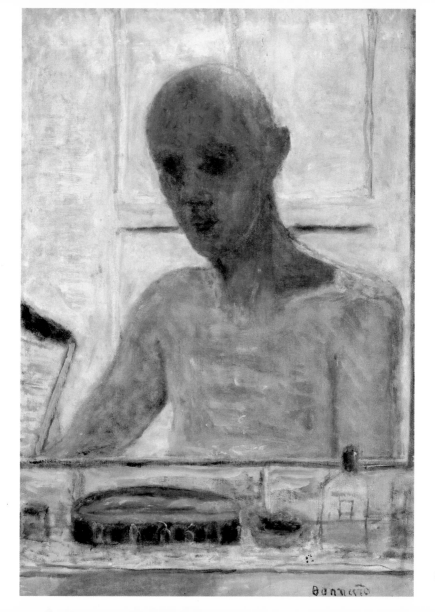

The basis of the harmony at which Bonnard aimed was a happy coexistence of man and nature. "One morning, on his way from 'Ma Roulotte', Bonnard instinctively walked towards two men discussing something near an ancient poplar tree, a tree which played an important role in the surrounding landscape and which he always greeted with a friendly smile whenever he happened to pass by. It turned out that the two men, the owner of the land and a timber-merchant, were discussing felling the tree. They seemed to have come to an agreement. Digging into his pocket, Bonnard produced more notes than the buyer could ever have offered,

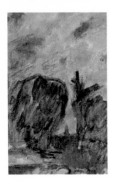

Afternoon Landscape

1945
Oil on canvas, 95 x 125 cm
Milwaukee Art Museum,
gift of Mr and Mrs Harry Lynde Bradley

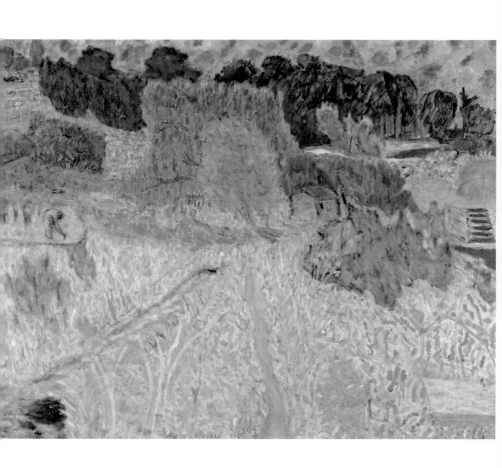

and the tree was saved. With his dachshund at his heel, Bonnard walked happily away, feeling the astonishment of the two men behind his back. He walked away with a tight heart because the old poplar would continue to hold up that vital landscape." Today Bonnard's popularity is on the rise. The public is becoming aware of the unique beauty of his paintings and of the wise warmth of the artist's spirit. The delight Bonnard took in nature is perhaps appreciated all the more today, when we find ourselves confronted with ecological problems at every turn.

Almond Tree in Bloom

1947
Oil on canvas, 55 x 37.5 cm
Musée National d'Art Moderne,
Centre Georges Pompidou, Paris

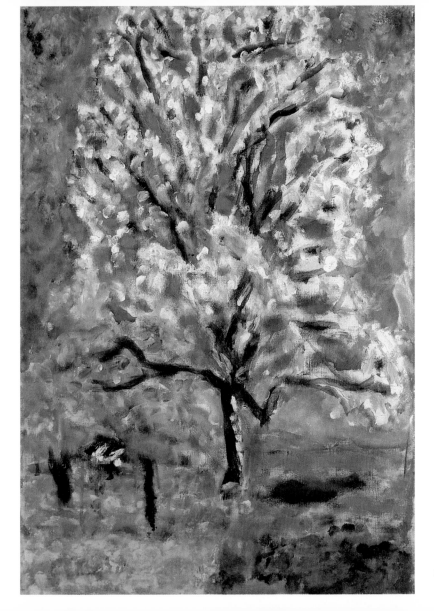

Index

N

O

P

T